CHEDDAR
THROUGH TIME
Andrew Pickering
& Nicola Foster

AMBERLEY

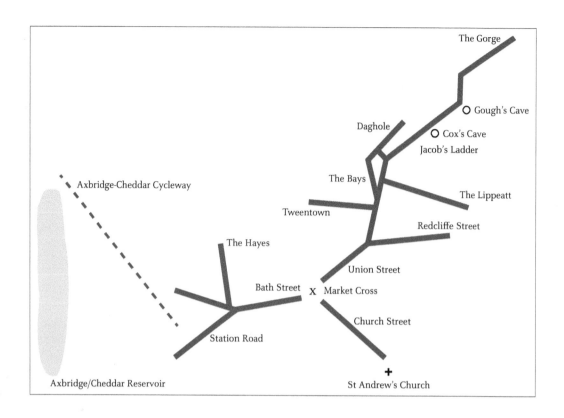

The Gorge

Gough's Cave

Cox's Cave

Jacob's Ladder

Daghole

The Bays

The Lippeatt

Tweentown

Redcliffe Street

The Hayes

Axbridge-Cheddar Cycleway

Union Street

Bath Street X Market Cross

Church Street

Station Road

Axbridge/Cheddar Reservoir

St Andrew's Church

First published, 2011
This edition published, 2015

Amberley Publishing
The Hill, Stroud
Gloucestershire, GL5 4EP

www.amberley-books.com

Copyright © Andrew Pickering & Nicola Foster,
2011, 2015

The right of Andrew Pickering & Nicola Foster to
be identified as the Author of this work has been
asserted in accordance with the Copyrights, Designs
and Patents Act 1988.

ISBN 978 1 4456 5071 5 (print)
ISBN 978 1 4456 5072 2 (ebook)

British Library Cataloguing in Publication Data.
A catalogue record for this book is available from
the British Library.

Typesetting by Amberley Publishing.
Printed in the UK.

Introduction

'For most people Cheddar means the three C's: Caves, Cliffs and Cheese.
To these might be added Church and Cross.'
Coysh A. W., Mason E. J., Waite V. (1954) *The Mendips*, Robert Hale, p. 169.

At the start of the twentieth century, the period from which many of the photographs in this collection date, Cheddar had a population of around 2,000. Well placed between the limestone hills to the north and the marshes to the south, the village had several industries including quarrying, papermaking and the manufacturing of shirts. Papermaking at Cheddar, exploiting pure Mendip spring water, dated from 1765. The railway, now dismantled, was hugely important for carrying raw materials, goods and produce in and out of the village. Electricity was provided by a gasometer, which provided the lighting for the famous caves close by.

The chief crops in the area were wheat, oats, barley, beans, peas, potatoes and fine strawberries. Plenty of Somerset cider has long been available in the vicinity of Cheddar. The sparkling, 'champagne', cider made by the Sealeys at nearby Rodney Stoke was dubbed 'the Wine of Wessex'. It was produced using traditional apple varieties, including Kingston Blacks, White Jerseys and Tom Tanners, as well as Herbert Harry Sealey's own draft – 'Stoke Reds'. By the end of the twentieth century, the major players in the cider industry, such as the Shepton Mallet-based company Showerings, had absorbed most of the independent producers, including Sealeys, and most of the apple juice for their cider was imported from France. However, in recent years companies such as Thatchers have revived an interest in beverages derived from locally grown English apple varieties.

By the middle of the twentieth century, the initiatives of two local entrepreneurial families over the last half-century – the Goughs and the Coxes – had reconfigured Cheddar's social and economic landscape:

> They still make cheese at Cheddar, but it is not now their sole occupation, for, alas, the town now specialises in tourist-luring and souvenir-selling, and the narrow road to the gorge is bristling with cafes, bric-a-brac shops, touters, and notices, and so chock-a-block with vehicles of every description, and sightseers of every type, that to reach the gorge at all is a physical struggle.
> Ruth Manning-Sanders (1949), *The West of England*, Batsford, p. 133.

However, the Cheddar tourist is not an invention of modern times. The earliest sightseeing reference for Cheddar dates from 1130 when Henry, the Archdeacon of Huntington, described

its caves, long before the discovery of the extent of Gough's and Cox's caverns, as 'under the ground which were like great halls or rooms'. Subsequent visitors included Daniel Defoe, who wrote a detailed commentary on the communal cheesemaking process.

These days, now that the railway has gone, tourists are most likely to start their excursion in the gorge itself, having parked in one of the parking bays in the vicinity of Gough's or Cox's caves. The narrow road has been widened and, although it can still be a very busy place, it is well worth taking the time to visit both the gorge and the fascinating village that lies at its foot. In addition to its cliffs, caves and cheese, Cheddar has its industrial and agricultural heritage and a rich social history, not least in relation to its many churches and schools.

This collection of archive and modern photographs introduces many of the village's most interesting sites, some long celebrated as major tourist attractions, others less well known but of great interest to inquisitive visitors and locals alike. Starting in the gorge above Gough's Cave and ending at the Axbridge Reservoir, this book can be used as a practical guide through Cheddar's busy highways and haunted byways.

Acknowledgements

Andrew Pickering: text and contemporary photographs. Nicola Foster: picture research and contemporary photographs.

The compiling of this book would not have been possible without the great generosity of a number of past and present residents of Cheddar who were willing to loan us their remarkable collections of photographs and associated memorabilia, and to share their extensive knowledge of the life of the village over the last 150 years. In particular, the authors extend their thanks to Hugh Alsop, Vera Bancroft, Mark Bailey, Mr Brice, Chris Bull, Anne Carney, Irene Gray, Audrey Hill, Terri King, Brooke McCarthy, Richard O'Conner, Brian Savill, Hazel Southall, Chris Simms, Gill Scard, Jackie Skidmore and Rex Thomas. Thanks also to the Bath Arms, Cheddar Bridge Touring Park, Cheddar First School, Cheddar Gorge Cheese Co., Cheddar Fire Brigade, Cheddar Post Office, Gough's Caves, Fairlands Middle School, Kings of Wessex Community School, St Andrew's church, Cheddar Brownies and the Strawberry Special (Draycott).

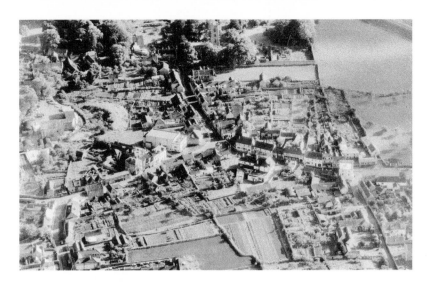

Aerial Views of Cheddar, Then and Now

The large white building in the earlier of the two photographs is the Regal Cinema, which was built in 1939. From the Market Cross in front of it, the heart of the village of Cheddar, spring Union Street to the left (east), Bath Street to the right (west) and Church Street beyond (south). St Andrew's church can be seen towards the top of the picture. There is plenty of evidence of cultivation taking place on allotments in open spaces, now largely built over. In the foreground of the colour photograph can be seen Cheddar's community school – the Kings of Wessex School – which occupies the site of what was formerly Manor Farm. Beyond the modern buildings stand the ruins of a fourteenth-century chapel, and archaeologists discovered the remains of a Saxon 'palace' here, which is now defined by concrete markers. Running along the bottom edge of the photograph is the old railway line, the Strawberry Line, now used as a cycleway linking Cheddar and Axbridge. Cheddar Gorge begins in the right-hand corner of the picture, and the observation tower at the top of Jacob's Ladder can be seen on the edge of the photograph.

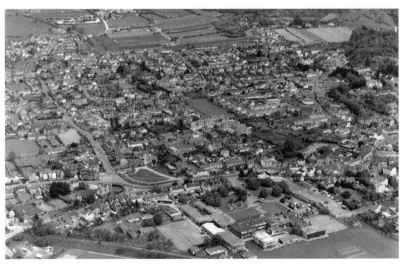

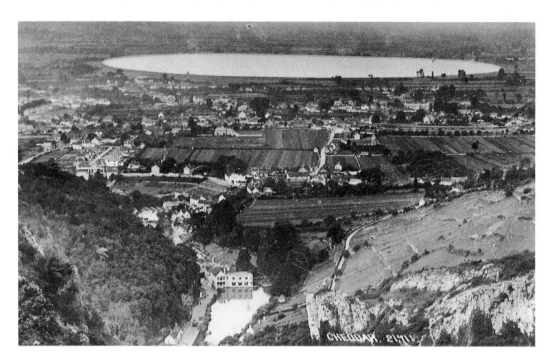

Views of Cheddar from the North Rim of the Gorge

The earlier of the two images shows empty space in the middle distance, which is now largely filled with residential buildings. In the foreground stands the Cliff Hotel (Cox's Mill Hotel) below its own manmade lake, which provided power in the days when it operated as a corn mill. In the early eighteenth century, the River Yeo, fed by nine springs in the gorge, powered twelve mills; by the end of the eighteenth century this had been reduced to four corn mills and three paper mills. The great Cheddar Reservoir, then as now, dominates the landscape from this high vantage point.

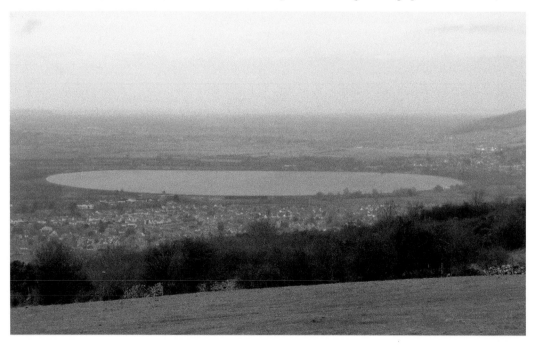

Cheddar Gorge and the River Yeo

Cheddar village and its famous Gorge lie at the foot of the southern edge of the Mendip Hills, between the seaside resort of Weston-Super-Mare and the historic city of Wells. The road that twists through the Gorge, first constructed in 1801, follows the course of the ancient subterranean stream that across the ages carved a passage through the limestone rock. The successor to the original stream emerges just below the entrance to Gough's Cave. The early photograph shows the view of the gorge from the banks of the Cheddar Yeo at Hythe, to the south-west of the village.

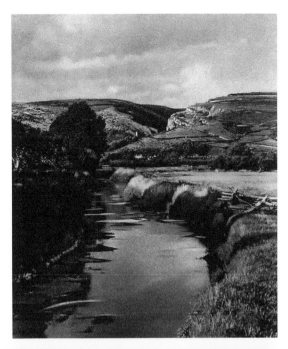

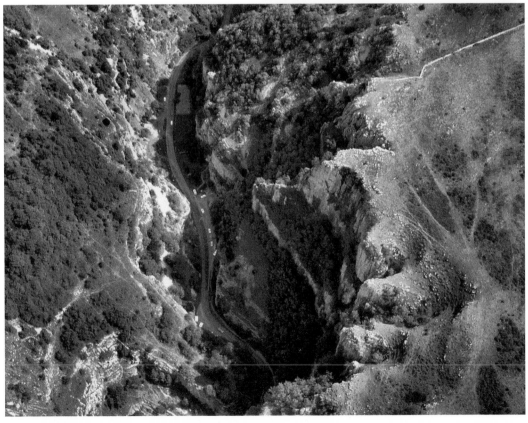

Photo by Adrian Pingstone, public domain.

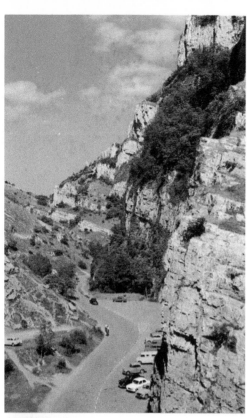

The Cliffs of Cheddar Gorge

The cliffs of Cheddar Gorge are as striking from above as below. Each year they attract thousands of tourists from all over the world, but comparatively few manage to climb one of the surrounding hills to gain views such as these.

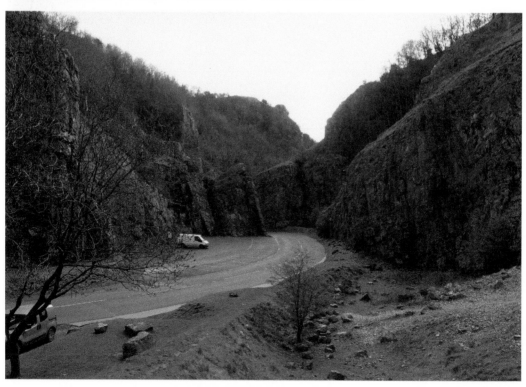

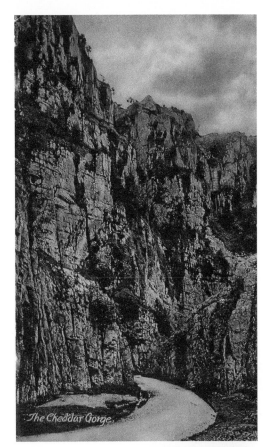

The Cheddar Gorge.

The Gorge

The land on the northern side of the road running through the Gorge is owned and maintained by the National Trust, while that on the south side is the property of the Marquess of Bath's Longleat Estate in Wiltshire, close to the Somerset border. The gorge is rich in rare flora and fauna including the unique Cheddar pink, whitebeams, peregrine falcons and dormice. It is also a designated site of Specific Scientific Interest (SSI).

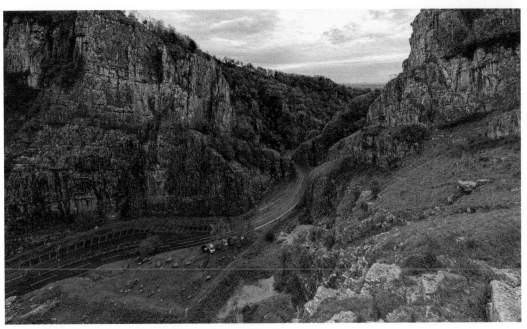

Photo by David Iliff. License: CC–BY–SA 3.0.

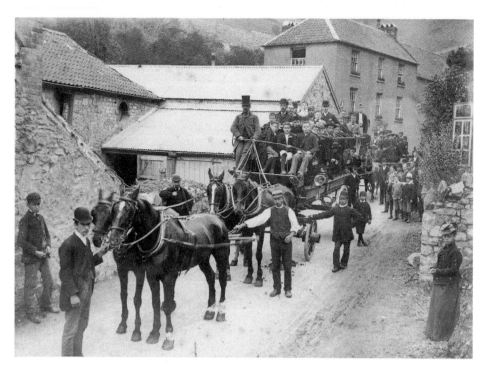

Travel to Cheddar

A hundred years ago, most visitors to Cheddar would have arrived by train and disembarked at Cheddar station a couple of miles to the south-west of the gorge. From here, the short journey to the famous caves would be on foot or, as in the picture shown, in some form of horse-drawn carriage. These days, now that the railway is closed, most visitors arrive by car or coach, and many start their visit from one of the many roadside parking bays located along both sides of the gorge directly to the north of the village.

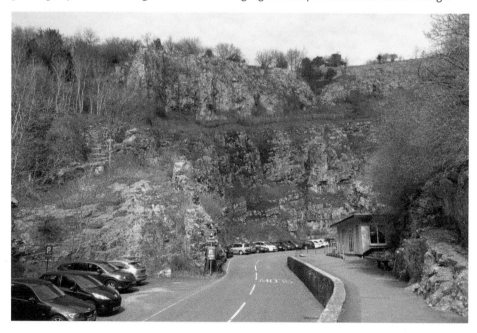

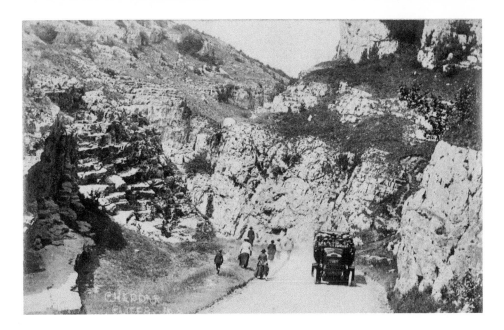

Holiday Traffic

In the picture above, a charabanc – the precursor of the modern coach – carries sightseers past a group of people taking a stroll along the gorge. The views they enjoyed are much the same as those shared by modern visitors. In the 1950s, one visitor observed that 'In summer it is easier to walk than take a car, for the approach roads are often congested with holiday traffic; in any case the cliffs rise so abruptly that it is quite impossible to see them properly from a saloon car.' (Coysh A. W., Mason E. J., Waite V. (1954) *The Mendips*, Robert Hale, p. 5)

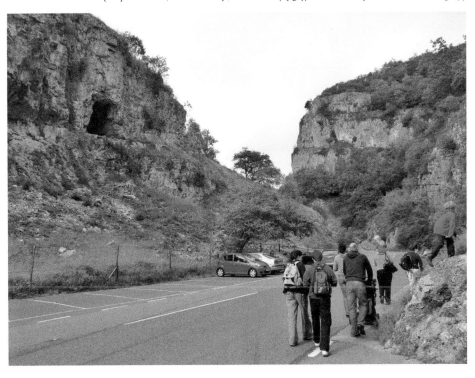

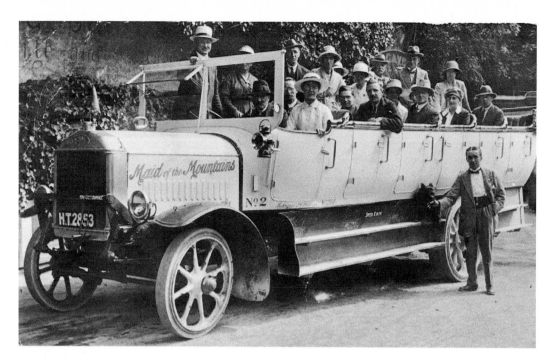

Open-Top Tours

The open-top tour of Cheddar Gorge is now generations old. The modern double-decker replaces the Maid of the Mountains charabanc used between the First and Secondw World Wars. It can be assumed it acquired its name in around 1930 when a film of the same name was made in the gorge.

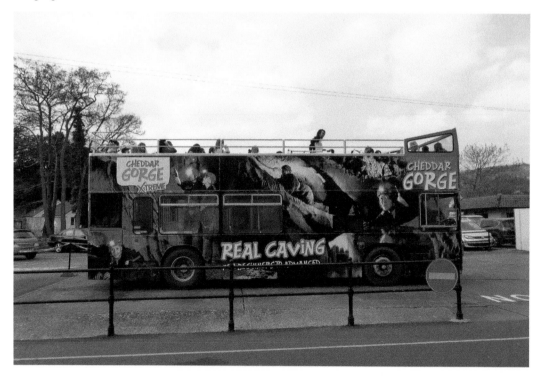

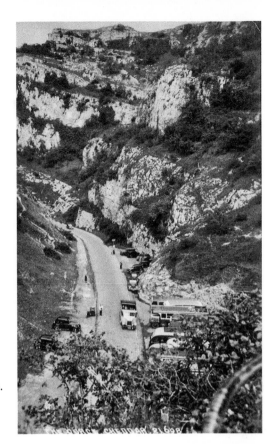

The Pass
By the middle of the twentieth century the first coaches were arriving in Cheddar Gorge. The spot from where the early photograph was taken is now a popular destination for those keen on climbing and abseiling.

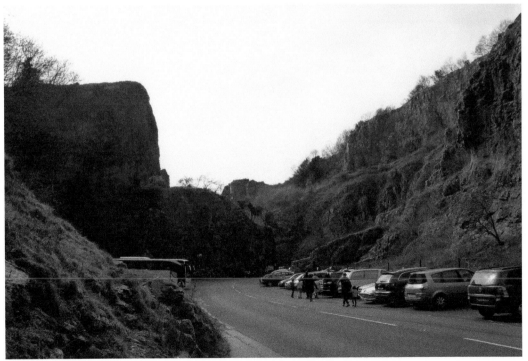

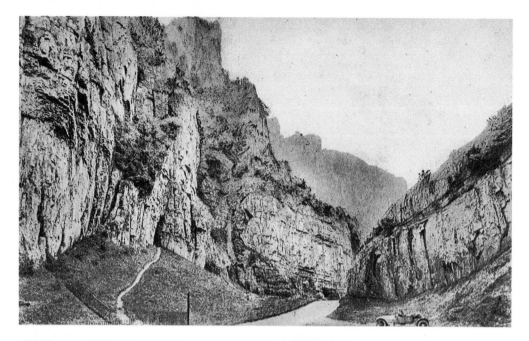

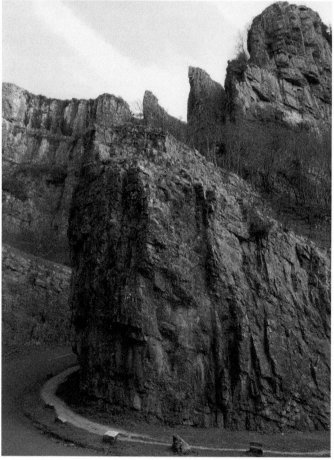

The Gorge: Beautiful but Potentially Hazardous

In 1939, two visitors, Mrs Kate Scott of Corsham and five-year-old Arthur John White of Combe Down, were killed by over half a ton of falling rocks, probably loosened by a combination of ivy growth and heavy rainfall. This tragedy occurred despite the fact that then, as now, the owners of the gorge routinely cut back and burned the scrub growing on the cliffs.

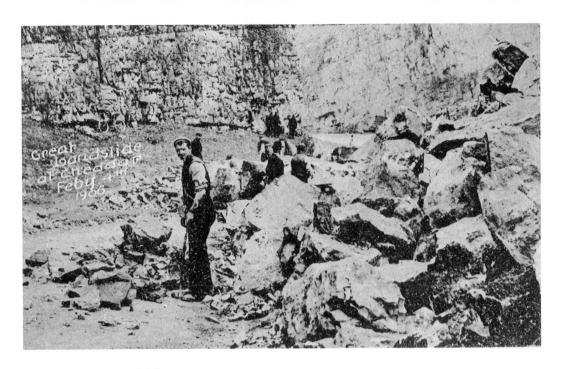

Great landslide at cheddar Feby 4th 1906

Wintertime Rockfalls

Wintertime rockfalls are a perennial and natural danger of Cheddar Gorge, but the falls and landslips were all the more likely when the cliff faces in the gorge were quarried. The rockfall shown in the picture is one that occurred in February 1906. Although such a major event is unlikely to affect modern visitors, traffic signs warn motorists of the potential for boulders lying in the road.

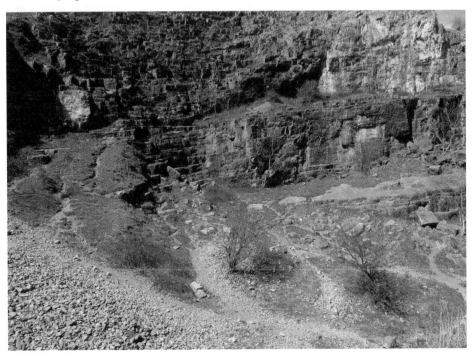

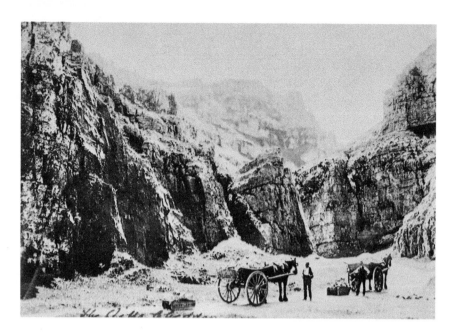

Batts Combe and Callow Rock

Quarrying took place in Cheddar Gorge for generations, but today it is an activity that is confined to two large quarries near to the village but away from the gorge itself – Batts Combe and Callow Rock. Founded by two brothers – George and Fred Ford – in 1926, Batts Combe quarry (*below*) was producing 4,000 tons of limestone a day by 2005. Everything quarried was sold to a single company until September 2010 – the Corus Group, which has since been absorbed into the giant multinational Tata Steel Europe.

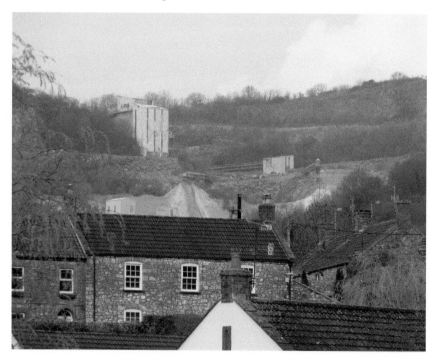

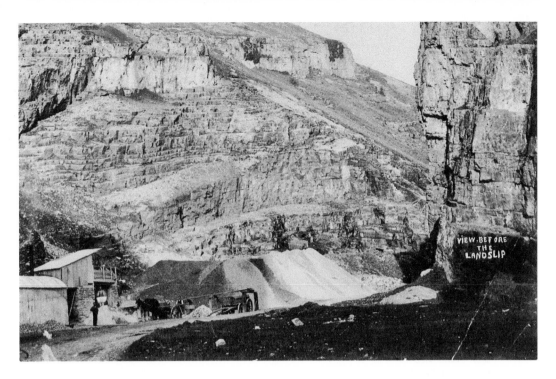

Quarry-Scarred Cliffs

Quarrying in the gorge came to an end after several great landslips at the turn of the nineteenth and twentieth centuries. However, the quarrying of stone in the past is abundantly evident in scarred cliffs along the narrow gorge and the occasional recesses providing convenient places for off-road parking. The colour photograph records a destructive landslip in Batts Combe quarry in 1968.

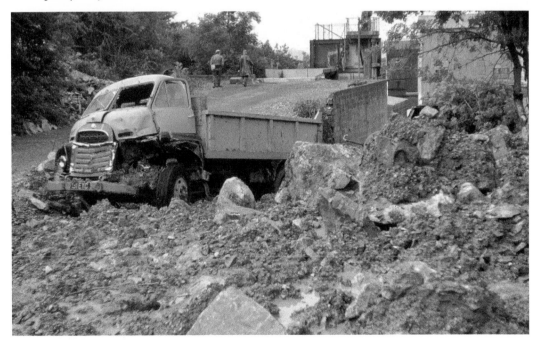

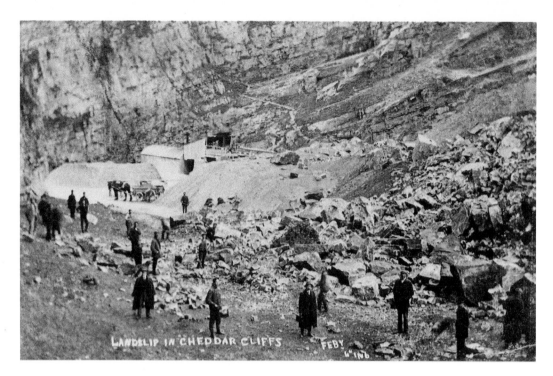

Landslips

These two photographs of quarry landslips show how history sometimes repeats itself. Clearly the quarrymen and other workers had a major task ahead of them in reopening access through the gorge after the major landslip of 1908. The more recent photograph is another picture taken at the time of the 1968 quarry slip.

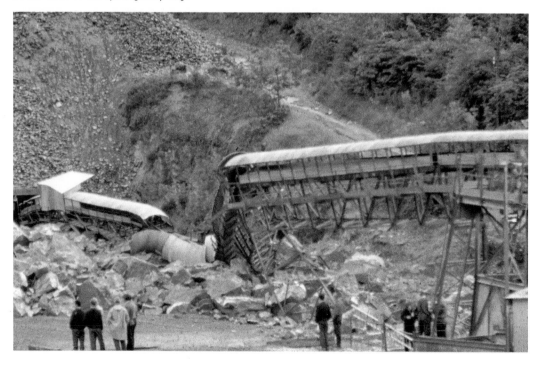

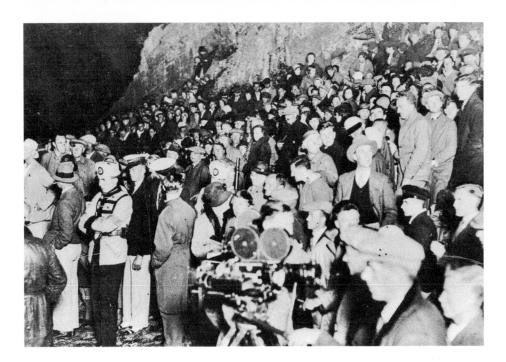

The Maid of the Mountains

In the early 1930s, Cheddar was the setting for a major movie. Released in September 1932, *The Maid of the Mountains* was a black-and-white film version of the popular three-act musical comedy, based on the book by Frederick Lonsdale and first put on stage in 1916. In 1995, scenes from the film, based on archive photographs, were reproduced by local people in the Cheddar Pageant.

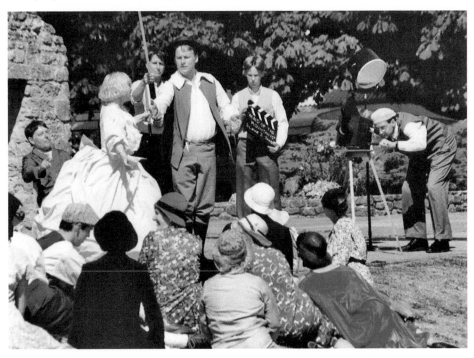

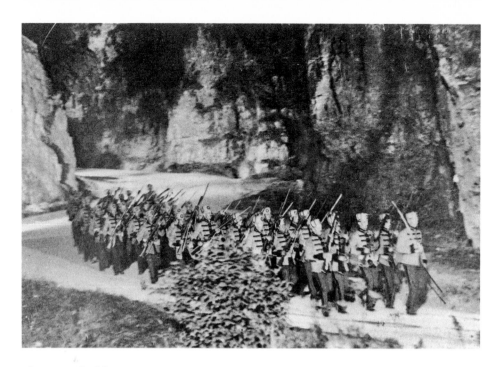

The 1995 Cheddar Pageant

Cheddar Gorge provided the perfect backdrop for *The Maid in the Mountains*' romantic Italianate mountain setting. The director was Lupino Lane, represented in the Cheddar pageant by the man in the foreground in the colour photograph. The 1995 Cheddar Pageant, itself already a part of Cheddar's rich social history, took place on 22 July and the two performances that day entertained and informed well over a thousand locals and visitors. The cast itself numbered 200 and another 100 constituted the backstage crew.

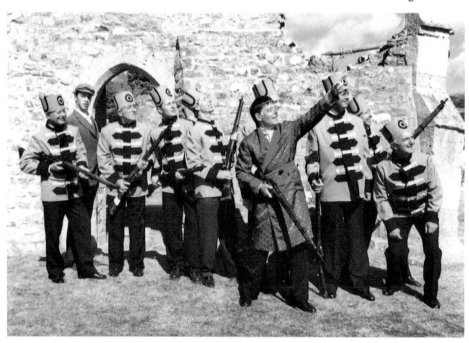

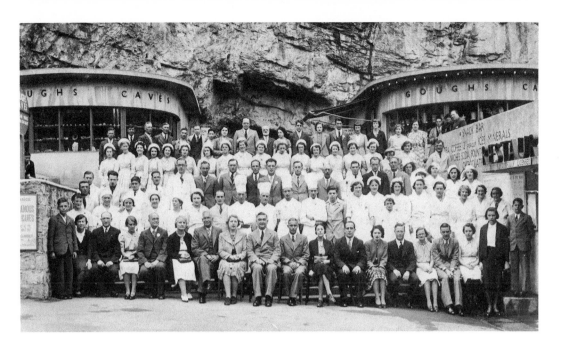

Gough's Cave

Gough's Cave is the main tourist attraction in Cheddar Gorge. Regarded as Britain's most beautiful limestone cave, among its many special features it has the largest colony of horseshoe bats in the United Kingdom. The older image, probably taken in the mid-1930s, shows the ninety-four staff of the visitor centre beside the entrance to the caves. The linear design of the newer buildings replaces the elegant curves of the distinctive Art Deco style of the earlier structure. This early all-concrete building had been completed in 1934 and the architect, Sir Geoffrey Jellicoe, won an award for his design, which included a glass-bottomed fish pond and fountain forming the roof and ceiling of the restaurant. This is now a terrace for outdoor eating.

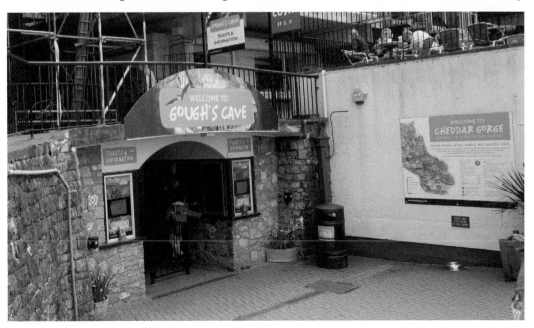

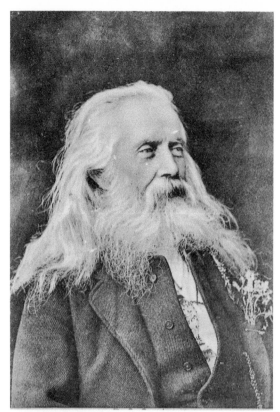

Richard Cox Gough

Richard Cox Gough (1827–1902) discovered and opened up the cave system, through the unexcavated entrance formerly called Sand Hole, at the foot of the cliffs, between 1892 and 1898. By the time of his death in 1902 the caves had become a major tourist attraction and, like the great man himself in this studio photograph, from 1899 they were 'illuminated by electricity'. In 1929, the admission charge was 1s. Gough had settled in Cheddar around 1870 after a career as a sea captain. Richard Gough's memorial stone can be found inside St Andrew's church.

Photo by LinscPaul; public domain.

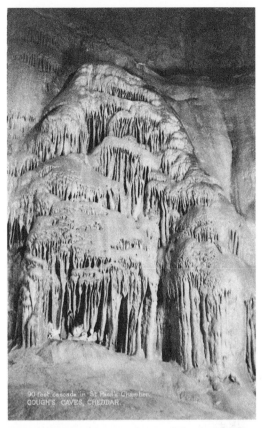

Gough's Cave, Unchanged

Thankfully, the fascinating geological formations within the caverns have been protected, and such wonders as the 90-foot cascade in St Paul's Chamber in the Gough's Cave complex remains unchanged in the short interval of time since this photograph was taken in the early twentieth century. Dissolved limestone accounts for the remarkable stalactites and stalagmites in the Cheddar cave systems. The relatively late discovery of these caves saved them from the damage suffered at nearby Wookey due to the activities of early souvenir hunters, including the famous seventeenth-century poet Alexander Pope who amassed a substantial collection of its 'sparry concretions' for his grotto in Twickenham.

90 feet cascade in St Paul's Chamber,
GOUGH'S CAVES, CHEDDAR.

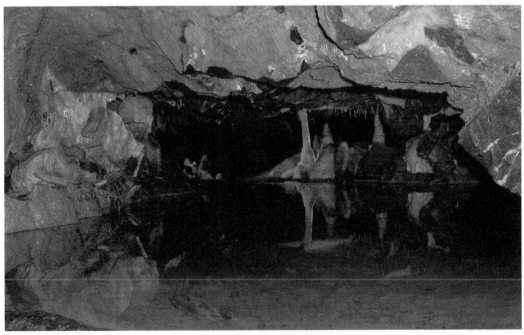

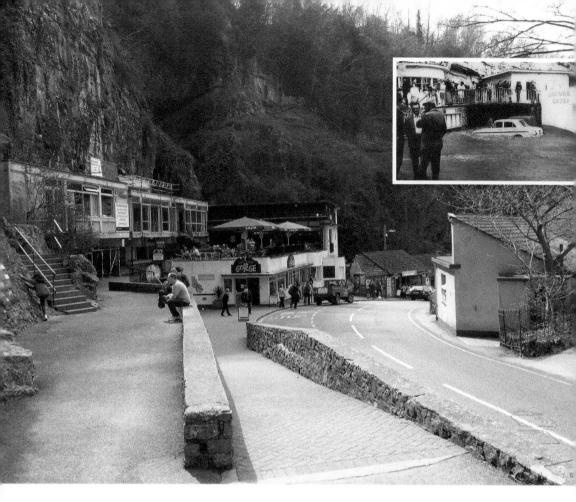

Trapped at the Cave Man

Typically, Gough's Cave is flooded once or twice a year. In 1968, the flood waters poured through the entrance of the caves for three days. At the time, Richard O'Connor was working as a barman with a friend, Peter Pilkington, in the Cave Man restaurant to the right of the entrance. He recalls the drama of the night of 10 July 1968: 'The Cave Man was bounded on one side by a river, on another by the sheer overhanging cliff and by the road, which was now a raging torrent of mud, boulders and water. We were trapped. I was in the downstairs bar when the steel door finally gave way. I managed to fling myself through the kitchens and I reached the back stairs just as the water arrived. We spent that night in darkness, apart from the lightning hitting the cliffs ... Downstairs was flooded to a depth of several feet, and there was a constant crash of rocks falling off the cliff onto the roof ... My overriding memory of the night was the noise of the boulders grinding around downstairs, the rocks bouncing off the roof, and of course the constant thunder. It was not a happy night.' The white car in the photograph belonged to the manager of Gough's Caves – Gerald Robertson.

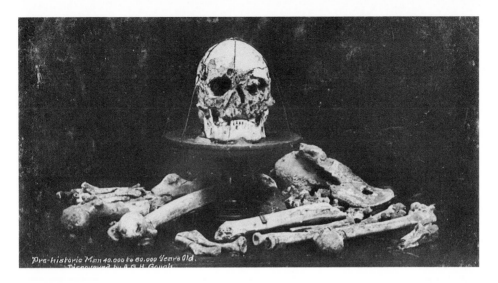

Pre-historic Man 40.000 to 80,000 Years Old.
Discovered by R. G. H. Gough.

Cheddar Man

The bones of Cheddar Man were examined by the curator of Taunton Museum, H. St George Gray, the assistant of two great early archaeologists – General Pitt Rivers and Arthur Bulleid. The postcard dates these remains, found in the entrance of Gough's Cave in 1902 by Richard Cox Gough's son, William, to between 40 and 80,000 years BP (Before Present). Archaeologists now believe the individual died around 9,000 years ago. DNA analysis of the bones in the late 1990s revealed that they belonged to a distant direct ancestor of a Cheddar school history teacher, Adrian Targett. Cheddar Man is now the focus of the small museum of archaeological material that was recently opened opposite Gough's Cave, having previously been located next to its entrance. Evidence of cut marks on human bones found in the vicinity (*below*) has led to much lurid speculation regarding acts of prehistoric cannibalism.

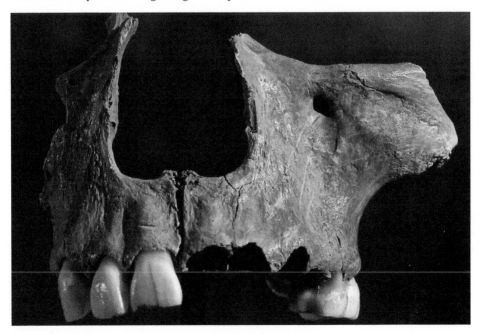

Photo by José-Manuel Benito Alvarez. License: CC–BY–SA 4.0.

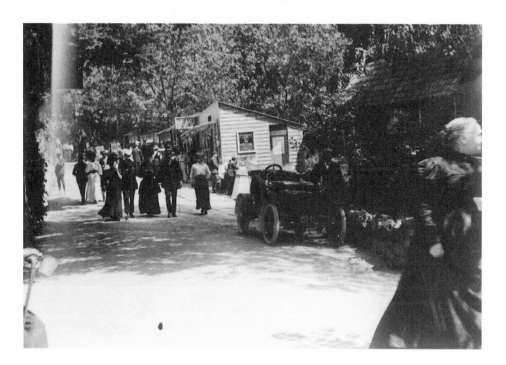

Tourism and Small Businesses

Tourists then and now wander up and down the cliffs a little beyond the entrance to Gough's Cave. In the early twentieth-century picture, the original arched entrance, very similar to the one that stands at the entrance to Jacob's Ladder, can just be seen in the distance where the buildings end. The shack to the right advertises 'Pictorial Postcards of Gough's Caves and Cheddar Cliffs', some of which, no doubt, have been reproduced in this collection.

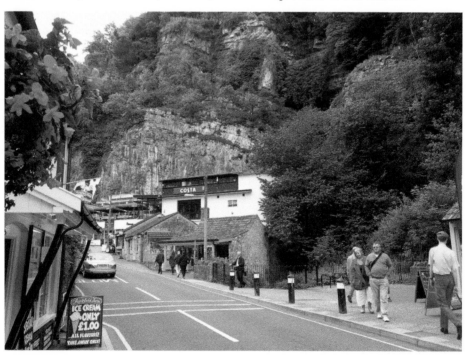

The Museum

The building that now houses the museum was formerly a restaurant with a 'tea garden' owned by the Gough family. Tourism in Cheddar has provided ample opportunities for small businesses for over 100 years.

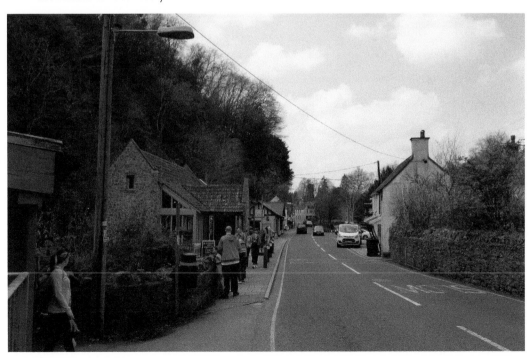

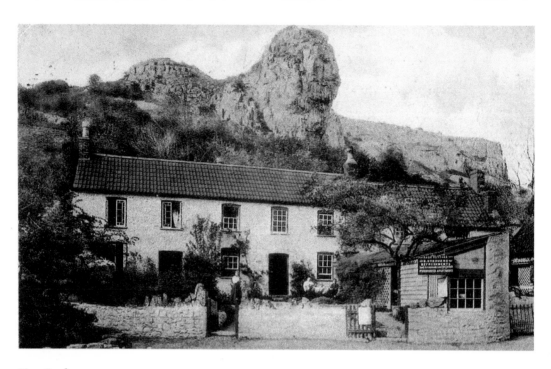

Lion Rock

Lion Rock is a striking outcrop overlooking the lower reaches of Cheddar Gorge, which really does look like a recumbent lion! The cottage below, Rose Cottage, retains the charming name it had when it functioned as a restaurant and bed and breakfast establishment run by a branch of the Gough family many years ago.

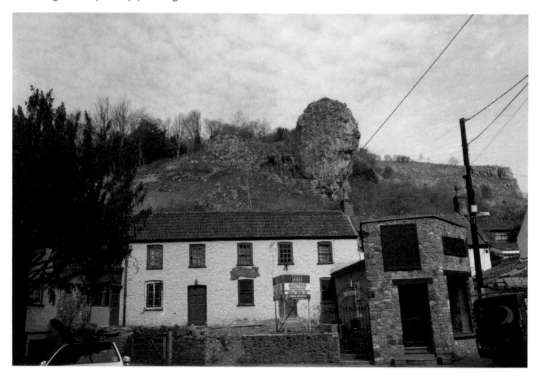

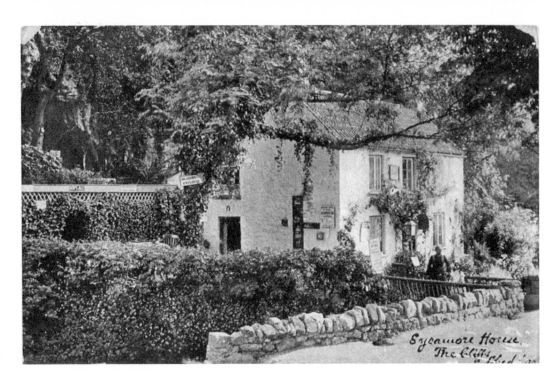

Sycamore Houswe

On the other side of the road, Sycamore House once stood on the site of the attractive and deceptively old-looking National Trust shop, formerly the tourist information centre. With its quaint bridge across the stream, it was a popular subject for Cheddar Gorge souvenir postcards. Due to damage caused by a rockfall, Sycamore House was demolished in 1959.

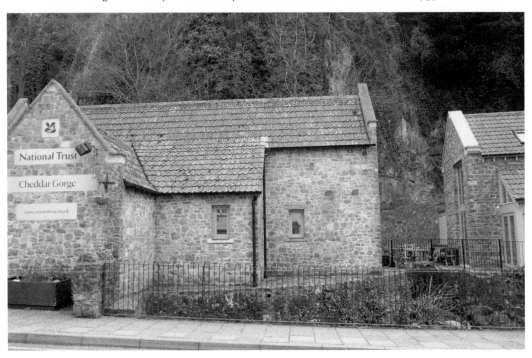

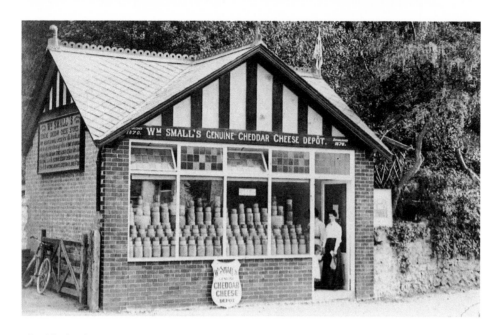

Cheddar's Cheese

Even more famous than its caves is Cheddar's cheese. Mr Small's cheesemongery, next door to the National Trust shop, remains a distinctive and rather charming tourist attraction. The business was established in 1870. The earliest known reference to Cheddar cheese dates from around 1170 when Henry II purchased a substantial quantity of it. Once upon a time, the only 'genuine' Cheddar cheese was that produced within a 30-mile radius of Wells Cathedral.

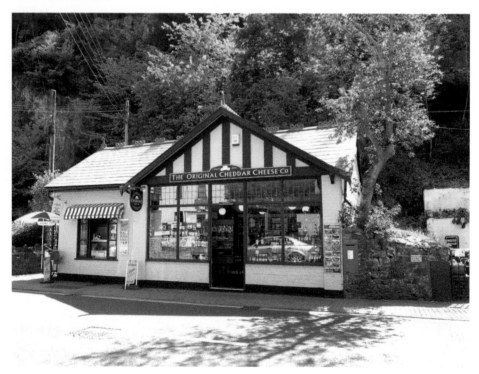

The Genuine Article

William Small became a master cheese taster in
1885, and his fine Cheddar cheese sold for 7*d* per
pound. The genuine Cheddar Cheese Store was
the main purveyor of cheese in Cheddar when
these premises were established in 1870. Half a
century ago it was lamented that 'the genuine
article seems now to be almost unobtainable by
the ordinary consumer, who is fobbed off with a
not very convincing imitation. ... As in so many
things we have retrogressed ...; now there are very
few, of the younger generation at least, who have
ever tasted genuine Cheddar cheese, and as a sign
of the times there is no longer that fascinating
cheese shop in Cheddar which in the days of my
youth sent delicious Cheddar cheeses of every
size and weight all over England and all over the
world.' (Coysh A. W., Mason E. J., Waite V. (1954)
The Mendips, Robert Hale, p. 169). Thankfully,
Cheddar cheese is once again being made in the
village by the Cheddar Gorge Cheese Co. The
picture below shows cheeses left to the mature in
a Cheddar cave.

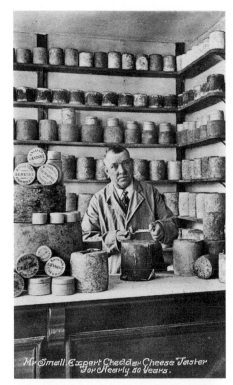

Mr Small Expert Cheddar Cheese Taster for Nearly 30 Years.

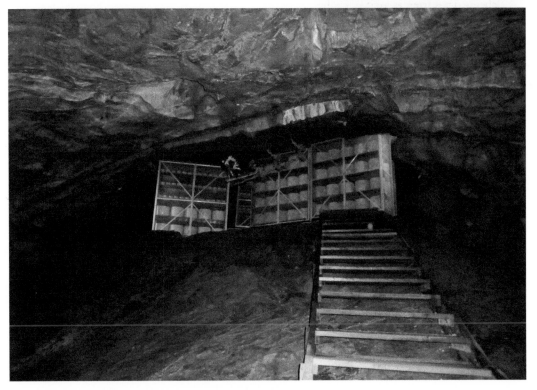

Photo by Gary Bembridge. License: CC–BY–SA 2.0.

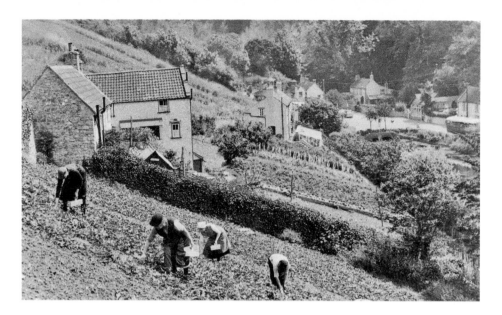

Strawberries

The growing and gathering of strawberries is a long-established business in the Cheddar Valley. They were first grown commercially by Samuel Spencer in 1901. In the photograph above, strawberry pickers are at work on the slopes overlooking Cheddar. The rich red loam soil, combined with heavy rainfall and the shelter of the Mendip Hills, diminishing the chances of early or late frosts, has made the Cheddar Valley a perfect location for strawberry growing. In the middle years of the twentieth century, land was so valuable because of the strawberry business that it was hard to come by for the purpose of building new houses.

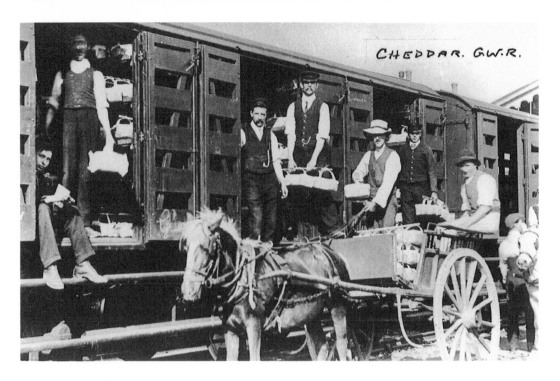

The Strawberry Line

The railway that once carried the strawberries from Cheddar was fondly known as 'the Strawberry Line'. Strawberries remain the pre-eminent crop of the extensive market gardens below the gorge. The Royal Sovereigns grown by the Victorians have been replaced by the hardier Cambridge varieties, and they are now grown in vast cloches to protect the delicate fruit from the elements.

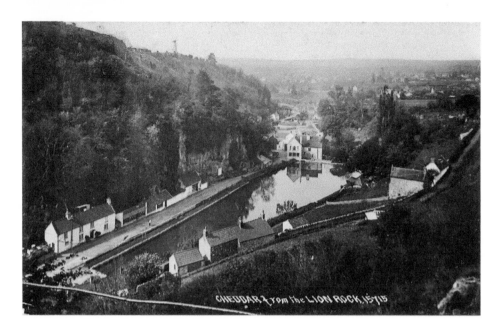

Cox's Mill

Cox's Mill, known more recently as Cox's Mill Hotel, is best viewed from the north edge of its header lake. It was, for many years, a corn mill owned by the family that gave its name to the cave system they opened up in the adjacent cliff face. In the older photograph, from the higher vantage point of Lion Rock, Holly House is on the left-hand side, and on the cliff top above the mill can be seen the top of Jacob's Ladder and the observation tower. In 1958, rising pop star Cliff Richard, aged eighteen and England's answer to Elvis Presley, stayed at the hotel when, appositely, it was known as the Cliff Hotel.

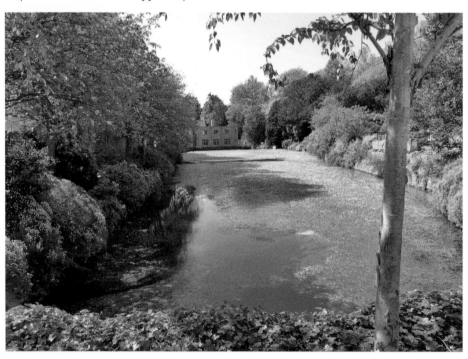

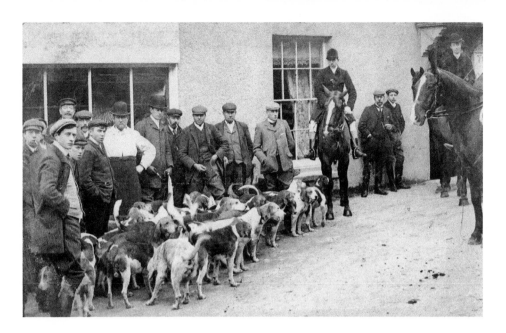

Paranormal Apparitions

Cox's Mill Hotel was the subject of paranormal speculation regarding evidence of a series of alleged hauntings. In 2007, a hotel guest was greatly disturbed by the vision of a ghostly woman in the hotel's main function room, who appeared to be placing the corpse of a baby into a fireplace. Further spectral appearances prompted the South West Paranormal Group to investigate, using state-of-the-art equipment to record anomalies in a number of rooms in the hotel. Their findings were recorded and published by author Mark Bailey. The early picture here suggests the hotel was the meeting place for the Mendip Hunt and Hounds in the days before their bloodsport was banned in the UK. Interestingly, one of the apparitions associated with the hotel is that of a man in the costume of a huntsman.

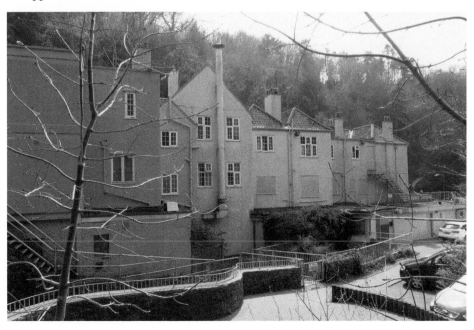

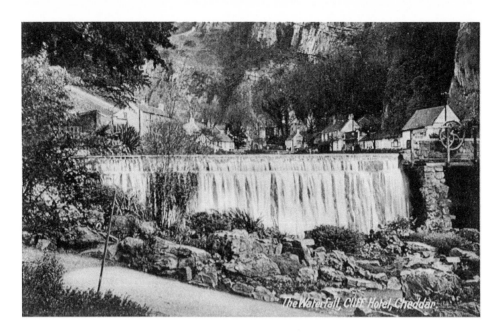

The Waterfall, Cliff Hotel, Cheddar.

The Waterfall

The waterfall adjacent to, and once serving, Cox's Mill. Cox's Mill Hotel and Restaurant, for many years known as the Cliff Hotel, has long been a popular viewpoint for visitors to Cheddar. The hotel is now closed and boarded up. Controversial plans have been proposed for the construction of a cable car service with the mill at its base, providing tourists with an alternative means of accessing the ridge at the top of Jacob's Ladder. A pressure group, the Friends of Cox's Mill Hotel, has been formed to safeguard this iconic building for the future.

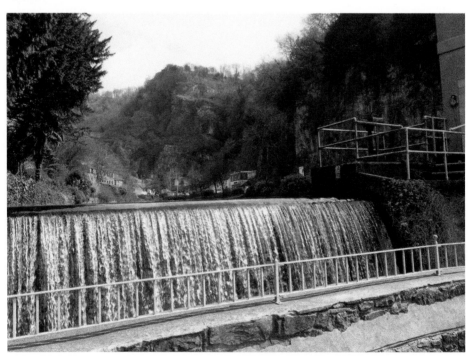

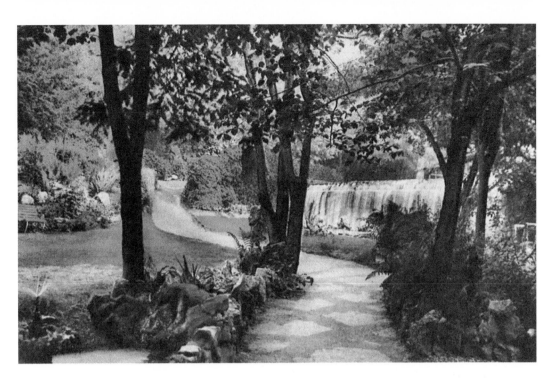

Cox's Mill Hotel Gardens
An impression of the garden's former glory is gained from the pathway above the waterfall where the unkempt remains of its rockeries and decorative plantings can still be identified on the steep banks above the hotel and header lake.

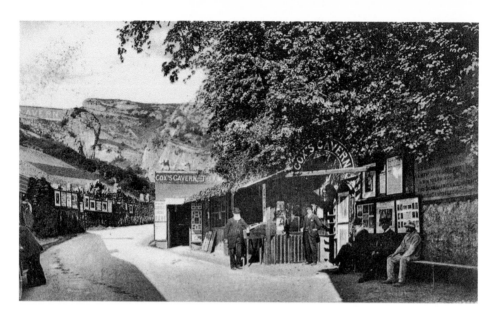

The Entrance to Cox's Cave

On the cliff face adjacent to Cox's Mill is the entrance to Cox's Cave. The old postcard shown here records a royal visit by 'the late King Edward VII' who died in 1910. It also remarks that of the 600 caves visited by one M. Martel of Paris, this was the one he most admired. A great banner emblazoned with the word 'CAVERN' appears to be suspended on the back of the lion of Lion Rock. Ever since George Cox discovered the caverns that bear his name in 1837 Cheddar has thrived on tourism. Entrance to Cox's Cave was 3s, 1s for those that belonged to a party of visitors. These days tickets – priced in pounds, not shillings – for all of the main attractions can be purchased at the central ticket office and shop at the foot of Jacob's Ladder. Cox's Cave was discovered by accident when George Cox was aiming to expand his mill premises in 1837. He made a suitable opening to the cavern by blasting the rock face with dynamite, in the process of which, much to the irritation of the hotelier, he blew in several hotel windows.

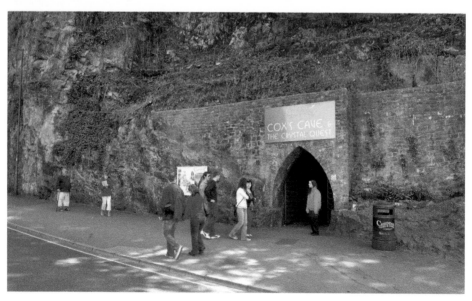

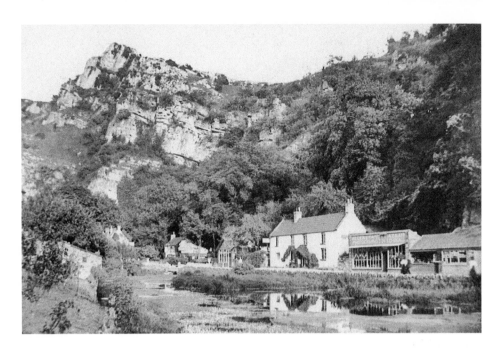

The Cliffs

In the summertime tourists flock to the cliffs – the name of the B3135 road that runs through the gorge. One visitor, A. W. Coysh, in a book published back in 1954, said, 'I like Cheddar best in the spring, before the crowds come. The little shops and cafés are freshly painted and have an expectant air, and the jackdaws chatter and scream as they carry building materials for their nests on the rock ledges.' (Coysh A. W., Mason E. J., Waite V. (1954) *The Mendips*, Robert Hale, p. 5) The archive photograph shows Allen's Fancy Bazaar (middle building) advertising photographs, toys and china. It has since acquired a second story but retains its flat roof and now specialises in the retail of teddy bears.

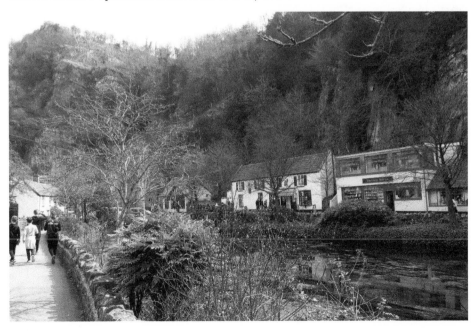

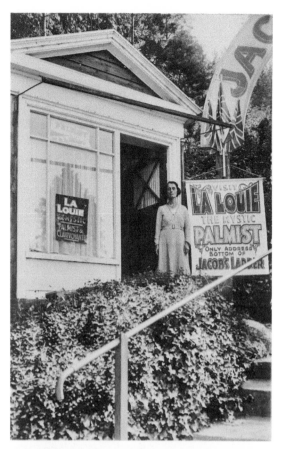

The Mystic Tower

La Louie the palm reader was renowned for accosting unsuspecting visitors on their way up to 'The Mystic Tower', also known as the White Tower, at the top of Jacob's Ladder. A creaky step alerted her to the presence of passers-by on their way up. These days, the hut on the site of her premises is occupied by information officers and guides on busy days at the height of the tourist season.

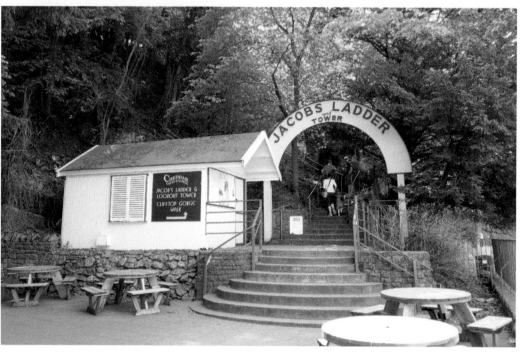

Jacob's Ladder

The 274 steps of Rowland Pavey's 'Jacob's Ladder' remain something of an endurance test for all but the fittest of visitors! At the time of their construction, towards the end of the first decade of the twentieth century, the intrepid tourist was rewarded with a pleasure garden known as 'Joyland', where hot meals could be purchased and diversions included a shooting gallery, a zipwire and skittles. Of these entertainments only the view from the observation tower remains. In the background of the earlier picture can be seen fields on the hill slope opposite, cultivated for the growing of strawberries.

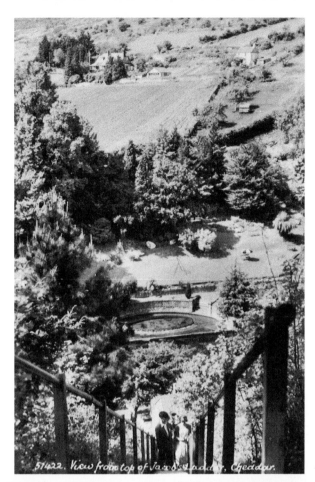

57422. View from top of Jacob's Ladder, Cheddar.

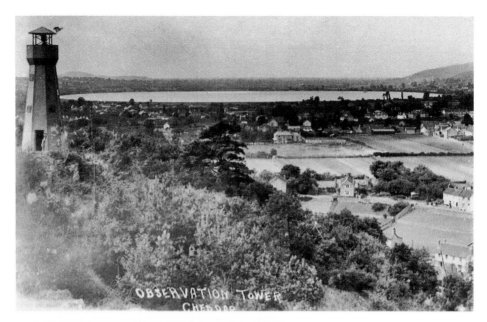

OBSERVATION TOWER
CHEDDAR

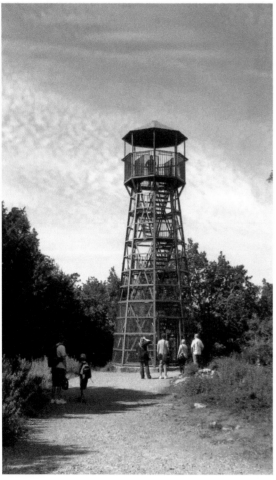

The Lookout Tower

High above Cheddar Gorge, the modern lookout Tower was constructed of wrought iron in 1936. Its forty-eight steps lead to spectacular views on a clear day. It replaces the earlier wooden construction, the Mystic Tower, built in 1908 by Richard Gough's good friend, Rowland Pavey – an alleged water diviner and magician. His one attempt to fly across the gorge using his homemade wings of whalebone and whaleskin ended in an ignominious crash-landing in the cliff-side gorse bushes. He ended his days in a mental institution. The Mystic Tower once housed a camera obscura; it was destroyed in a gale in the 1930s.

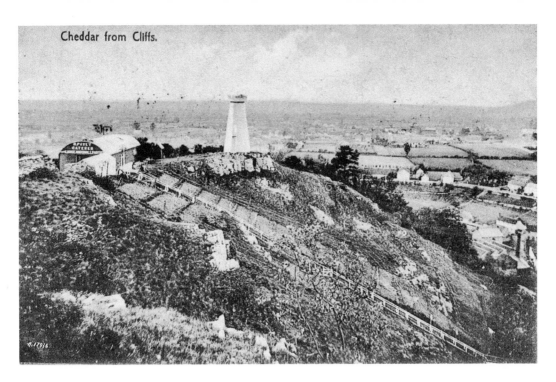

Cheddar from Cliffs.

Joyland

No trace remains of Pavey's utilitarian, shed-like catering outlet. The food was cooked down in the valley, presumably in the kitchens of Pavey's Hotel, and winched up to the hungry diners above. The recent photograph, taken from the top of the observation tower, shows Batts Combe quarry in the distance.

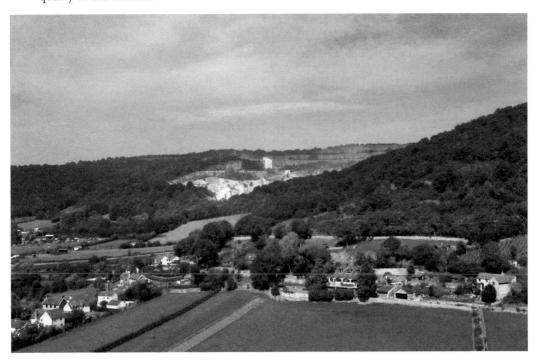

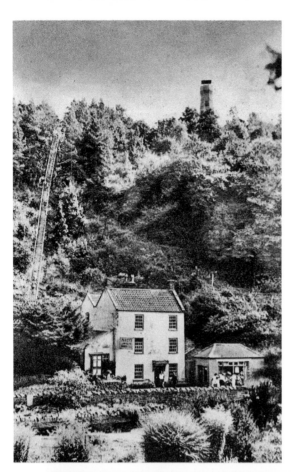

Pavey's Temperance Hotel

Pavey's Temperance Hotel stood near the foot of the eccentric local entrepreneur Rowland Pavey's Jacob's Ladder. The front of the original two-bay hotel structure was removed when the main road running up the gorge was widened. The back bay, visible in the modern photograph, now houses Old Rowland's Gift Shop, specialising in Christmas decorations.

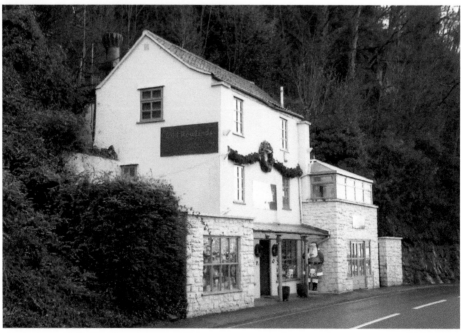

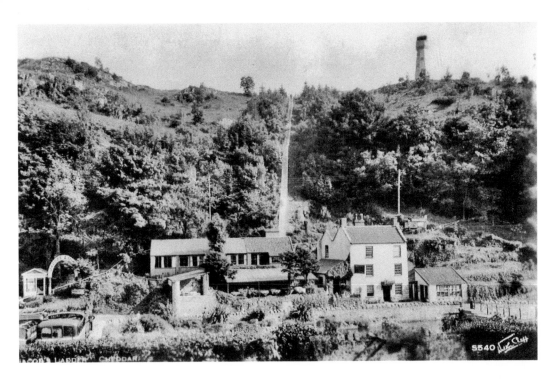

Pavey's Hotel and Jacob's Ladder

A view from across the valley shows Jacob's Ladder before it became largely obscured by trees and bushes. Rowland Pavey's Temperance Hotel in the foreground has lost its front bay in more recent times due to widening of the road. Both the Mystic Tower and Jacob's Ladder are clearly visible in the old photograph, but trees completely obscure them from sight today. Pavey's tearooms, adjacent to the hotel, could sit 400 diners at a time.

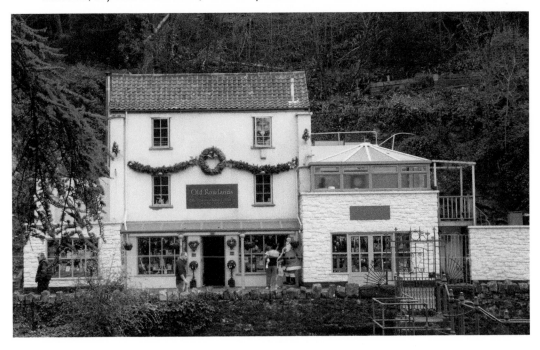

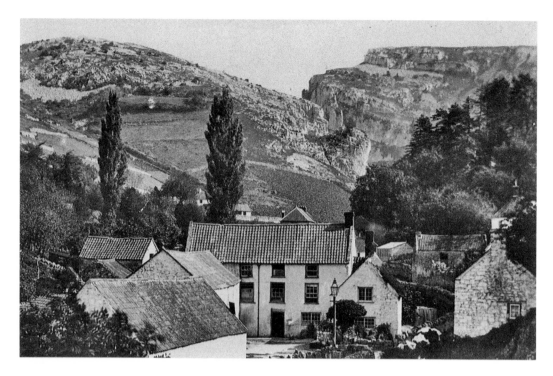

The Rotary Garden

Middle Mill was a corn mill over the road from Pavey's Temperance Hotel. Long since demolished, the site is now known as 'The Rotary Garden' and is funded by the local Rotary Club. It was first planted in 1975. In the early photograph, Pavey's Mill is on the right from a view looking towards the Gorge. In the recent photograph, taken from Jacob's Ladder, the corner of Pavey's Hotel, now Old Rowland's Gift Shop, is to the left and the Rotary Garden is beyond the white car.

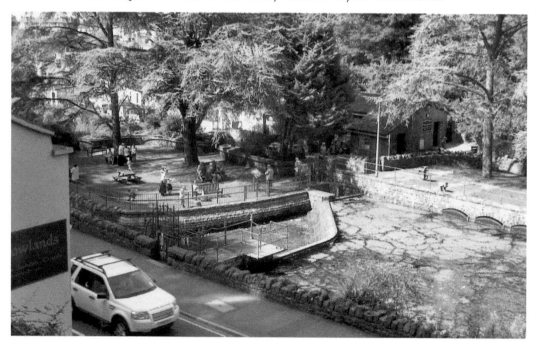

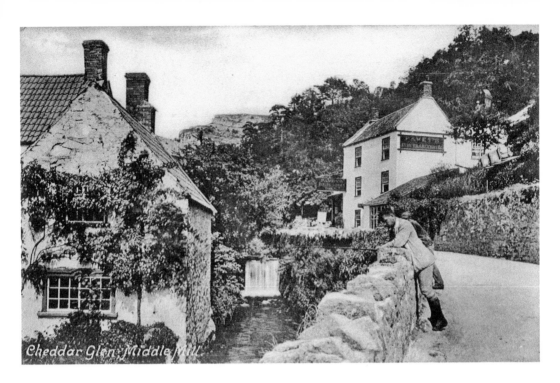

Middle Mill

The picture above appears to show men fishing in the mill leat between Pavey's Hotel and Middle Mill. Though the Middle Mill has now been demolished and replaced by attractive overgrown rock gardens, the fast flowing stream remains to delight Cheddar's numerous visitors.

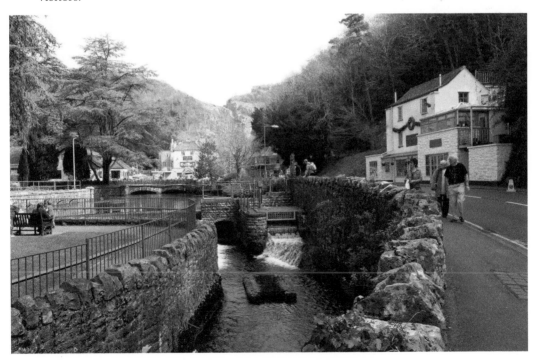

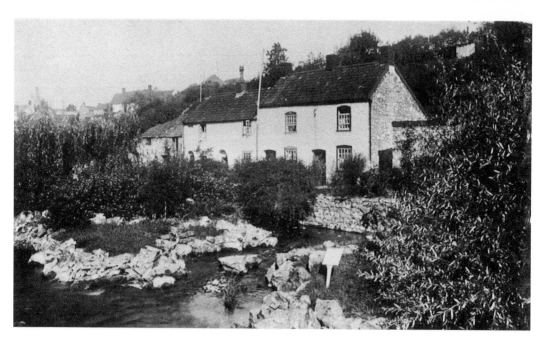

Daghole
Beyond the site of Middle Mill is Daghole, which is still an attractive and interesting row of cottages and shops.

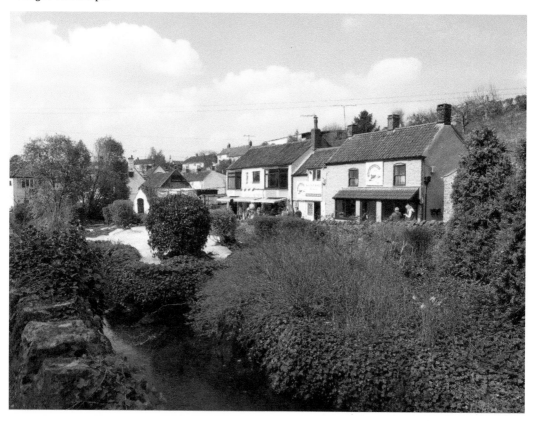

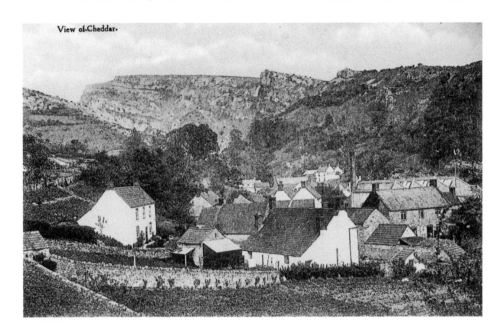

View of Cheddar.

Shirt Manufacturing

The 1902 Ordnance Survey map for Cheddar identifies no less than three shirt factories in the village. For the reissue of this map, Mike Bone has written, 'Two of the old mills had been converted into shirt manufactories by 1902 and a third ... on Tweentown. The making of shirts, blouses and detached collars of the time was quite significant in the late Victorian economy of Somerset and North Devon ... The Cheddar factories were, apparently, quite short-lived. Production soon moved to Taunton, causing widespread unemployment and much emigration to America. Two of these factories survive, identified by their distinctive jagged north-light roof structures.' The factory at the foot of the gorge, now housing shops and cafés, can be seen in both of the photographs on this page. Beyond its chimney (now gone) in the archive photograph can be seen the two-bay structure of Pavey's Temperance Hotel.

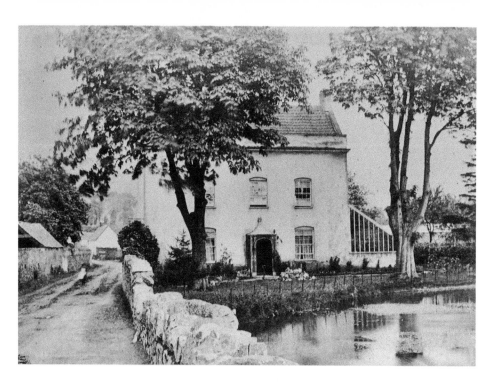

The Factory from the White Hart Inn

The modern photograph on this page shows the shirt factory from the parking bays beside the White Hart Inn. The manager lived nearby in the substantial house shown in the archive picture.

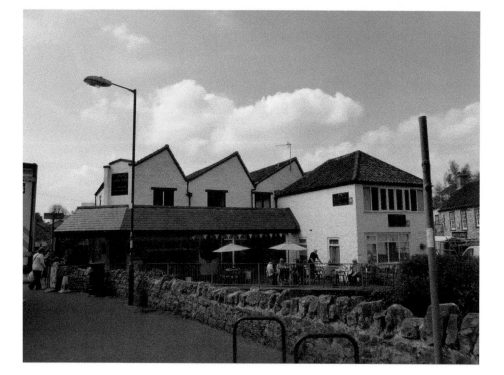

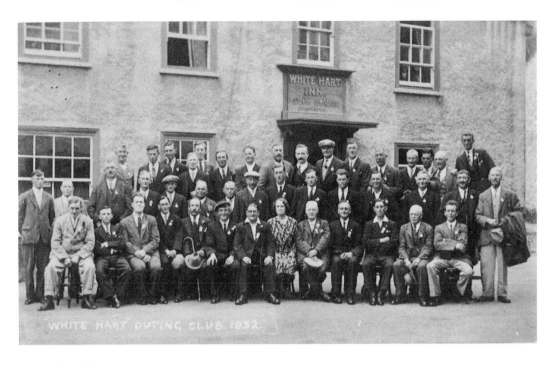

The White Hart

To the side of the old shirt factory is the White Hart in the Bays – a lane that runs parallel to the main street beside the cliffs. Taken in 1932, the photograph above shows members of the White Hart Outing Club. The Proprietor, Emma Durbin, presumably, is the lone woman sitting in the centre of what was clearly a gentlemans' club. The White Hart remains a popular destination for thirsty and hungry tourists.

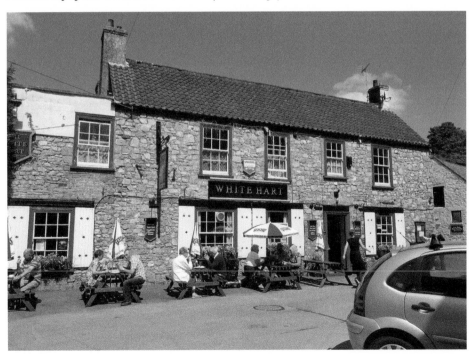

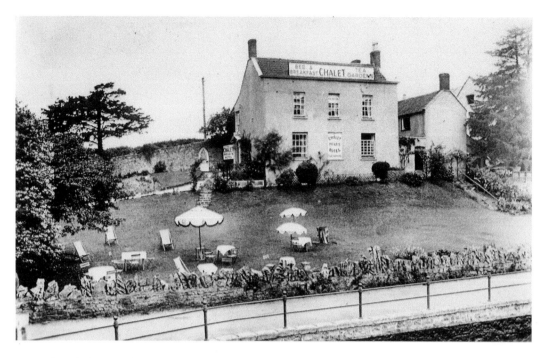

The Chalet Hotel

Below the White Hart is the Bays Pond, formed in 1827 on a bend of the river to serve the neighbouring mill. The Chalet Hotel, now a private house, occupied a prime position on the Bays on the far side of the pond. It provided another popular 'tea garden', with tables and umbrellas providing shade for summertime visitors.

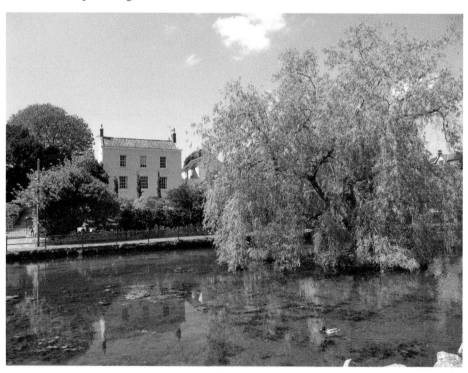

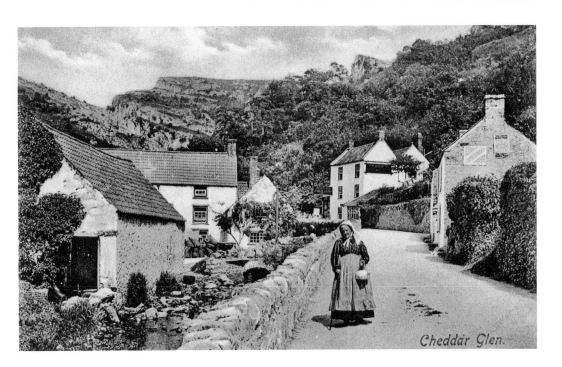

Cheddar Glen.

Cheddar Glen

The archive photograph shows local woman Sally Spencer posing below Middle Mill (*left*) and Pavey's Hotel (*right*). It was taken in 1908. The road at this point is now wider, and the mill has long since been demolished. The front bay of Pavey's and another commercial establishment, 'Cheese Cottage' as it was called in the 1920s, between Sally and the hotel, were also taken down when the road was widened in the 1960s.

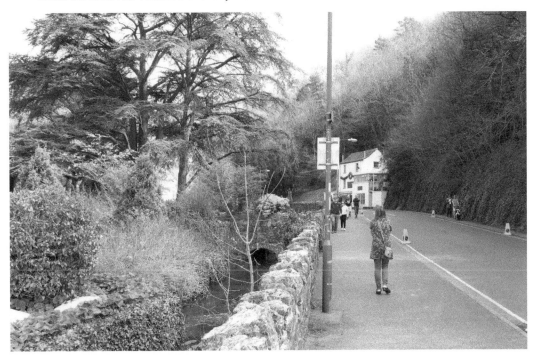

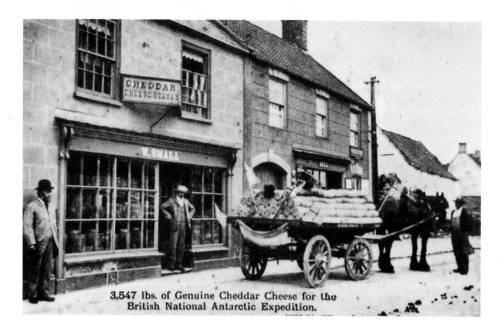

3,547 lbs. of Genuine Cheddar Cheese for the
British National Antarctic Expedition.

The Cheddar Gorge Cheese Co.

A little further along the cliffs, on the right at the end of the gorge, is the award-winning Cheddar Gorge Cheese Co. shop and exhibition offering customers the opportunity to taste a very wide range of cheddars; it even sells its own rustic pottery platters, embossed with the phrase 'History in the Making' on which to serve them. It will deliver its cheeses to any address in the European Union. This is very much in the tradition of the village, which supplied cheeses to the court of Charles II in seventeenth-century London and, according to the caption of the photograph above, supplied 3,547 lbs of Cheddar cheese for Scott's 1901 Antarctic expedition from their premises in Bath Street.

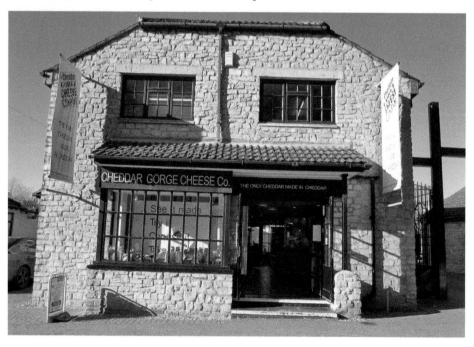

The Lippiatt

Over the road from the car park and terminus for the Cheddar Gorge tour buses is the Lippiatt, 'a bit of old Cheddar'– a steep narrow road, lined on one side with old cottages built on the steep slope that runs to the east of the village and connects Lippiatt Lane with The Cliffs. The curious name Lippiatt appears in various different forms on postcards dating from the first part of the twentieth century, including 'Lippet' and 'Lappats'. The word is thought to derive from an Old English word for a cattle gate, which would have prevented cattle and deer from coming into the village. This is one of three old lanes with a similar affix that denotes their original function: the others are Wideatts and Venns Gate. A playful resident has renamed the first cottage on the left of the modern photograph 'Lilliput'.

CHEDDAR. — A Bit of "Old Cheddar". — LL.

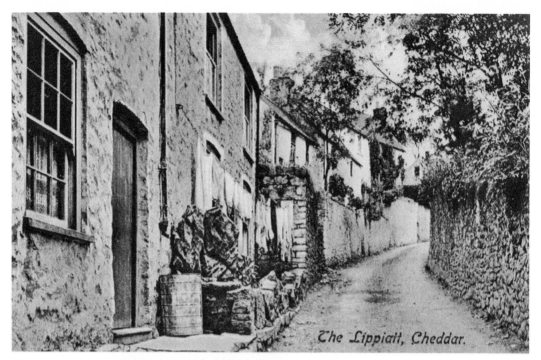

The Lippiatt, Cheddar.

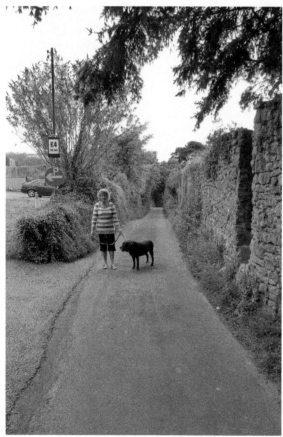

The Woman in Black

At seven o'clock in the evening on 13 December 2004, Tina Nicholls (*shown in the photograph below*) was walking her dog Oscar along the lane when, at the point she is standing in the photograph but facing away from the camera, she saw the figure of an elderly woman in black with a white apron and cap who also had a dog with her, and coming out of the gloom before her was shrouded by a strong smell of tobacco smoke. Tina watched as the woman stepped to the right and disappeared into the bushes. Certain she had seen a ghost, she mentioned her frightening experience to a friend who promptly identified the apparition as Betsy Card, a well known and much photographed pipe-smoking local woman who lived in the village a century before.

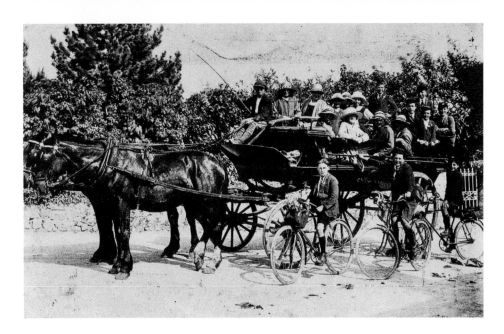

Bicycles, Then and Now

You are highly unlikely to see a cart loaded with visitors in Cheddar these days, but the bicycle has been a regular feature of the Cheddar village landscape for over a century. Despite the great increase in motorised traffic that makes cycling on the Mendips a precarious activity, every year thousands of visitors arrive at Cheddar on the seat of a bike. The bicycles in the recent picture have been parked just beyond the Cheddar Gorge coach terminus. The old photograph shows a group of boys and girls with, probably, their teachers. The boys are in a school uniform of caps, blazers and short trousers. Notice how young the boy driving the cart appears to be.

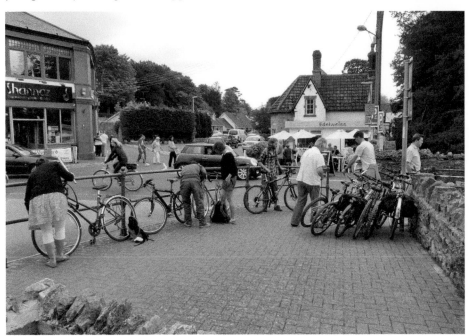

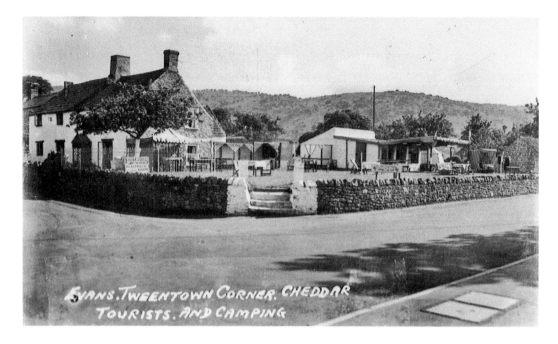

Tweentown Corner

Just beyond the junction of the Bays and Cliff Street, the road known as 'Tweentown' does in a sense, as the name implies, divide Cheddar in two, with 'tourist' Cheddar to the north along the gorge and residential Cheddar and the heart of the village to the south, east and west. The picture identifies Evans' campsite as being on Tweentown Corner. Evans' campsite was located on the junction of Tweentown and Upper North Street, a couple of hundred yards along the B3135. The campsite has gone, but the retaining wall, with the entrance filled in, remains.

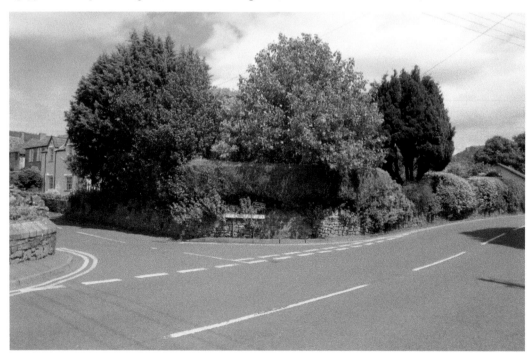

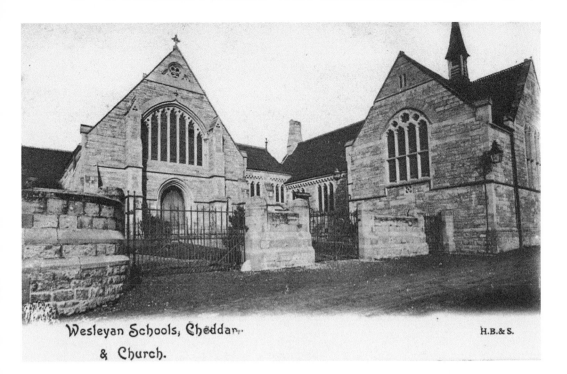

Wesleyan Schools, Cheddar.
& Church.

H.B.& S.

The Methodist Memorial Church
The Methodist Memorial church further along Cliff Street was erected in 1820, with additions and alterations from then until 1897. Apparently no less than five churches constructed to the same design were built in the Cheddar Valley.

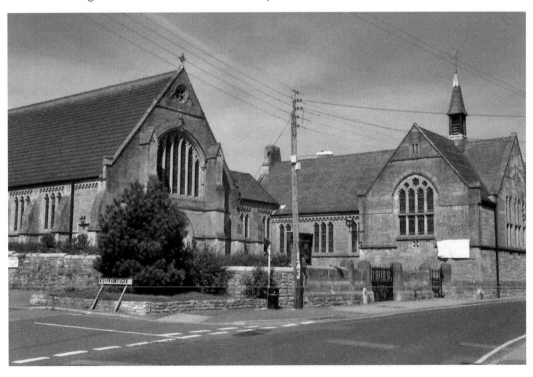

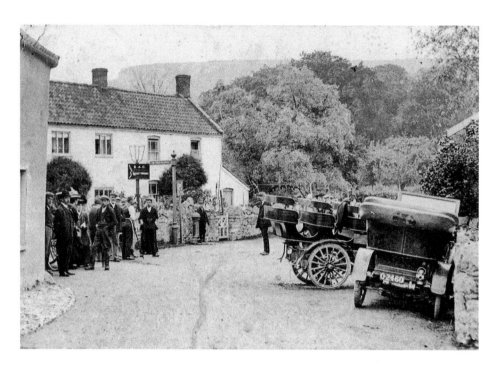

Car Collision
At the end of Cliff Street a car collided with a Burnell Brothers' fourteen-person charabanc in around 1910. The long building in the background on Coles Corner, where Cliff Street, Union Street and Redcliffe Street meet, is named Redcliffe Court.

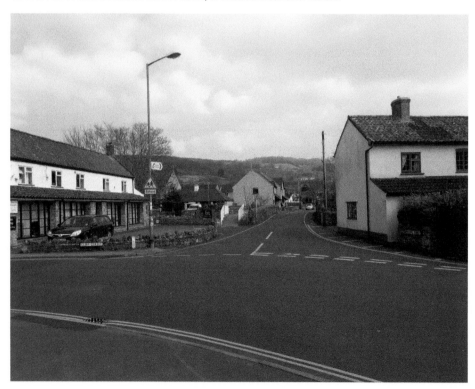

Reading, Writing, Arithmetic, Grammar, Geography and History

Just beyond the crash site, on the left, are two adjoining properties that once housed the Cheddar British School, which subsequently evolved into Cheddar First School, located in The Hayes. On its opening in 1845, it declared that 'The system of education to be adopted will be that of the British and Foreign School Society, which comprises the teaching of Reading, Writing, Arithmetic, Grammar, Geography and History. The only Religious Instruction given in the School, will be that derived from Scripture Lessons, and no Sectarian Catechism or Creed will be taught. The rate of payment will be one penny per week.' By the time the older photograph here was taken, it had already relocated to its new premises in The Hayes. On the back is inscribed 'Aunt Susan outside her house', which is identified as 'Swiss Cottage' – the name by which it is still known.

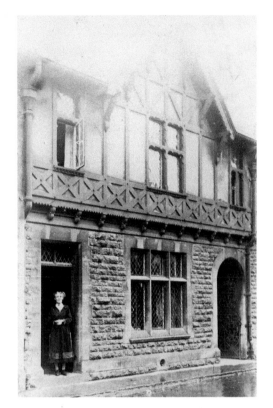

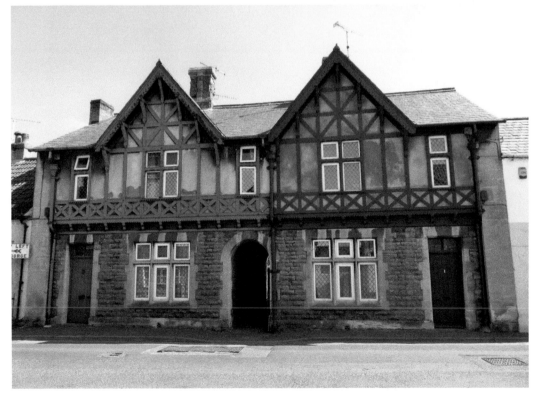

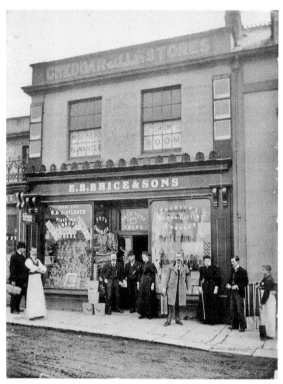

Cheddar Valley Stores
The premises shown in this splendid photograph of the 'Cheddar Valley Stores', since 1976, now house Cheddar's library in Union Street. The Brice family continued trading next door until 1997. In addition to the tea, cocoa, wine, spirits and 'Thomson's Close-fitting Corsets', the faded painted lettering above reveals that E. B. Brice & Sons offered a range of other goods and services including boots, shoes and tailoring.

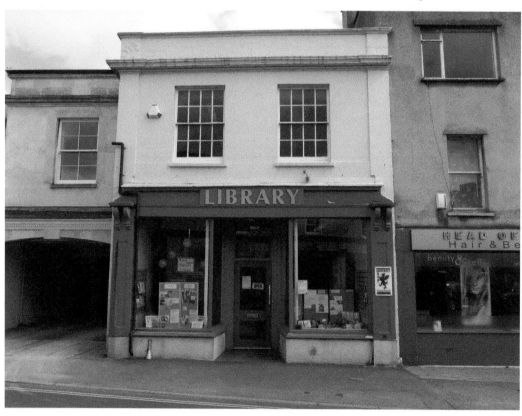

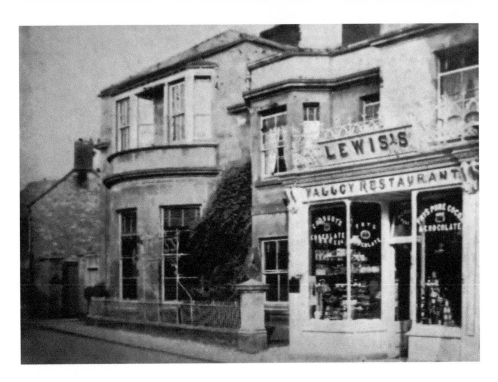

Lewis' Hotel

Between the old British School and what is now Cheddar Library was Lewis' Hotel and its adjoining valley restaurant. In the 1930s, it was one of at least eight Cheddar establishments offering 'comfortable' lodgings on 'moderate' terms in an era of local tourism less dominated than now by the day-tripper.

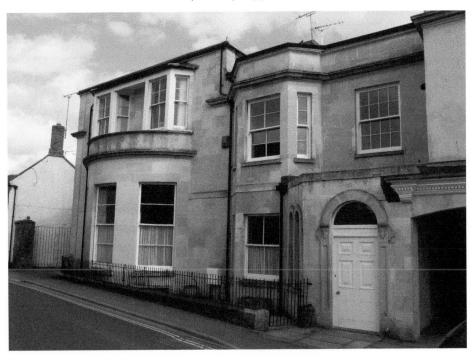

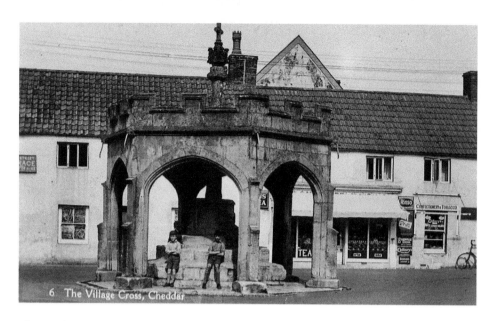

6 The Village Cross, Cheddar

The Market Cross

If Cheddar village has a centre it is its fifteenth-century market cross, or 'butter cross', upon which its three main streets – Bath Street, Union Street and Church Street – converge. Bath Street and Union Street formerly shared a single name – High Cross Street. On the evidence of these two photographs, it would appear that the Market Cross has not suffered any kind of damage in the decades since the older picture was taken. In fact, the half of the structure facing the camera was badly damaged in a traffic accident in January 2000, and its restoration was not completed until 2002. The Market Cross was damaged again in 2012 when a taxi driver sneezed and crashed into it. In the fifty years or so since the earlier picture (*seen above*) was taken, the appearance of the buildings on the far (gorge) side of the Market Cross, on the corner of Union Street, has scarcely changed. The premises once occupied by the grocer's on the right-hand side are now available to let, and the sign for Bath Street Garage, advertising hire cars, has gone.

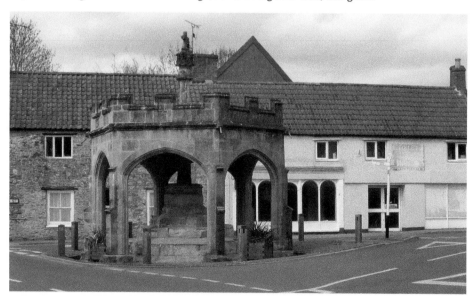

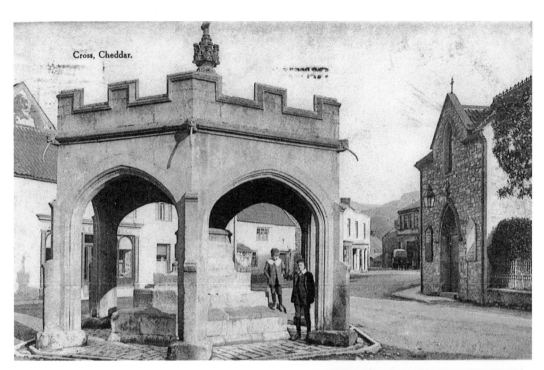

Cross, Cheddar.

Christ Church
Beyond the two boys sporting Edwardian 'Eton' collars, on the corner of Union Street, is a substantial chapel called Christ church – a place of worship for the Reformed Episcopal Church. Before its demolition in 1939, Christ church served as a store for Brice's – the department store that occupied the premises and which now houses Cheddar Library. The attractive, old-fashioned way sign adjacent to the Market Cross is a relatively recent addition.

65

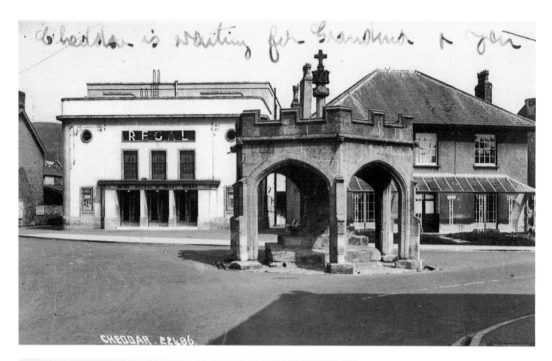

Cheddar is waiting for Grandma + you

CHEDDAR. 22486.

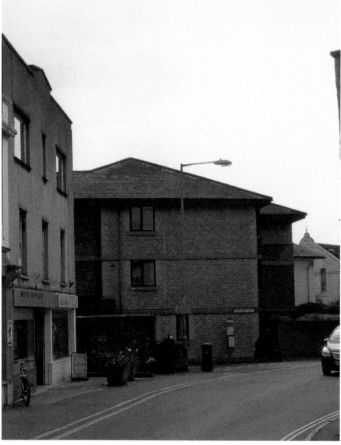

The Regal Cinema

In 1939, the Regal Cinema was built on the site of Christ church and opened just a couple of weeks after the outbreak of the Second World War in September of that year. At the time this photograph was taken it was showing a film called *Smart Woman*, which was made in 1948. The Regal could seat 400, but its days were numbered with the advent of television and it eventually closed in 1958. The Regal eventually became a car showroom before it too was demolished and replaced by the 'Homestead' retirement apartments shown in the recent photograph. The older photograph is annotated: 'Cheddar is waiting for Grandma and You'.

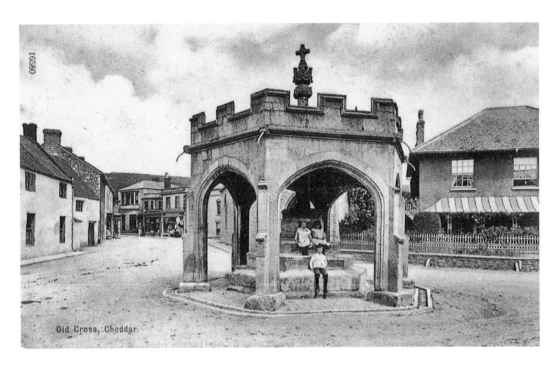

Old Cross, Cheddar.

Market Cross Hotel

Next door to the Christ church/Regal Cinema/Homestead site stood the Market Cross Hotel, now Arundel House, sporting what appears to be a fabric canopy in the earlier photograph before it was replaced with one made of glass. Next door stands Christ church and in the background, in Union Street, is Brice's department store. To this day, Arundel House retains its distinctive and attractive canopy; the shutters are more recent additions.

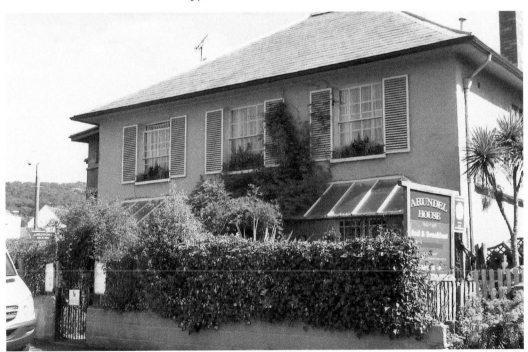

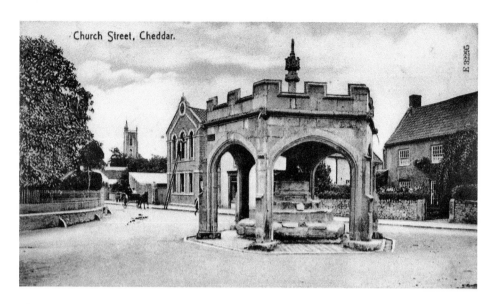

Church Street, Cheddar.

The Parish Hall

This rather grand building next door to Court House in Church Street now houses the parish hall. Formerly it served as the village's Literary Institute, established some time before 1870. Over the years it was a canteen for servicemen in the Second World War, which was a place for card players to meet (strictly by invitation only!) and a space for concerts, readings and other cultural activities. In the old photograph someone is up a ladder, possibly cleaning the building's windows, as a horse and gig rattles by. St Andrews church tower is in the distance. The building to the right was demolished not long after the photograph was taken. Court House, just beyond the parish hall, can be seen in the modern photograph.

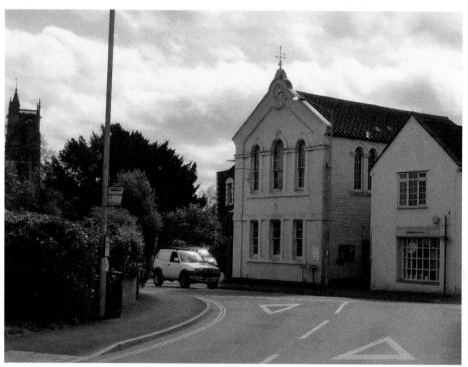

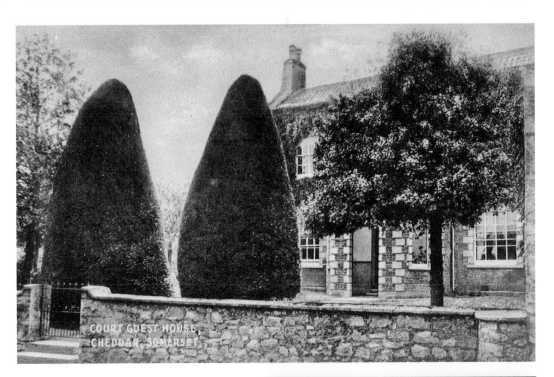

The Court House

The Court House was largely rebuilt
in red brick on the site of much earlier
structures in Victorian times. Manorial
court sittings were held there since
medieval times. For the last thirty years
or so it has been a retirement home.

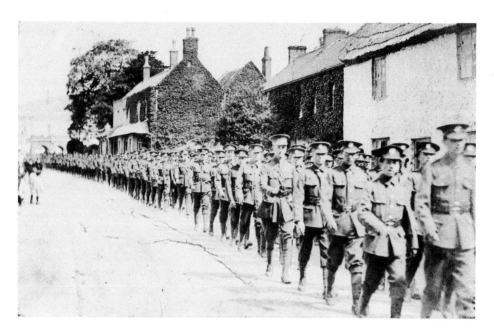

The Royal Gloucestershire Hussars Imperial Yeomanry

The archive photograph shows off the Royal Gloucestershire Hussars Imperial Yeomanry who camped at Cheddar in May 1904 on the site of what subsequently became the Axbridge Reservoir. They are shown marching along Church Street, on the other side of the road to Court House, and in the direction of St Andrews' church. Large numbers of children skipped school to watch them parade through the village. Note the canopy in front of the property to their left; this, and another one next door, much like that which adorns Arundel House, have survived to the present day. The Butter Cross can be seen in the background of both pictures.

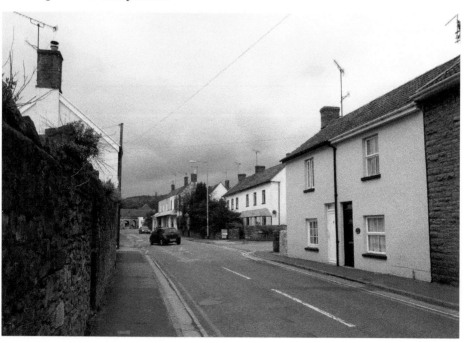

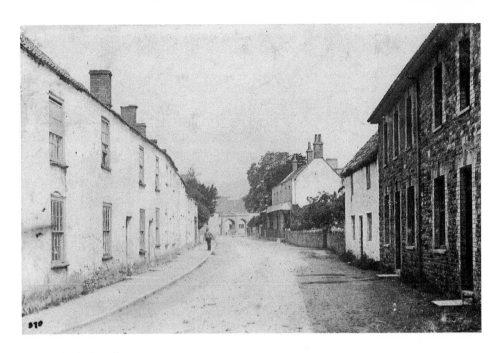

The End of Church Street

The houses at the end of Church Street, shown on the right of these photographs, have changed very little over the years. The earlier whitewashed cottage is no longer thatched, and the houses next door have gained a pavement but lost their boot scrapers. The modern photograph shows an archway at the end of the terrace and what was probably a store room into which heavy objects could be winched up from a cart stationed under the arch below. The terrace on the left was demolished to accommodate the large hall known as Church House, which was constructed opposite the church sometime before it appeared on the 1902 Ordnance Survey map.

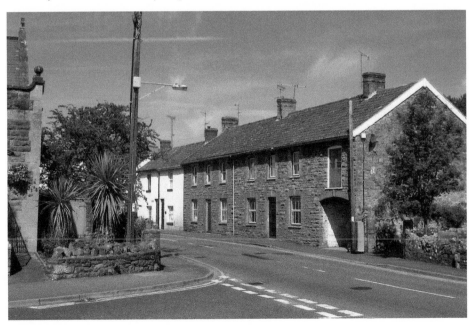

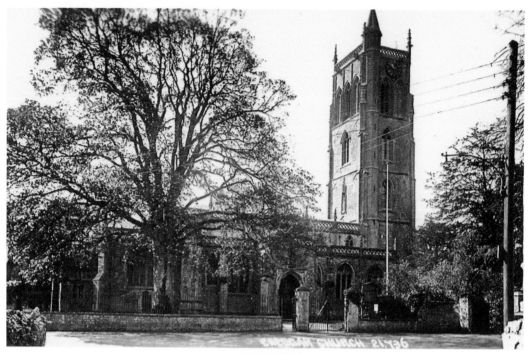

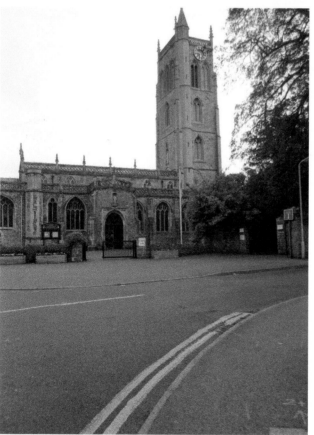

St Andrew's Church

Built between 1350 and 1450, St Andrew's church has changed little since it was restored in 1873 by William Butterfield. The 30-metre tall tower, dating from around 1423 and considered the finest example of the Cheddar Valley type, houses a mid-eighteenth-century bell made by Thomas Bilbie. Originally based in nearby Chew Stoke, the men of the Bilbie family of bellmakers were reputed to have been long haired and savage looking. Legend has it that they would only ever cast their famous bells by the light of a full moon at midnight.

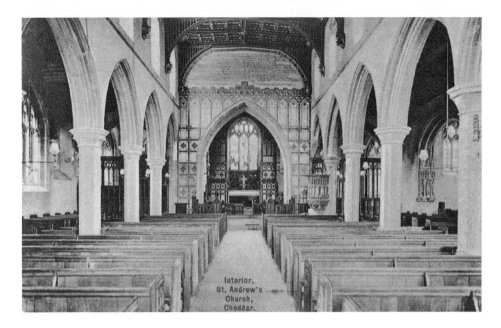

Interior,
St. Andrew's
Church,
Cheddar.

Interior Decoration

The obliteration of earlier wall decorations in medieval churches is usually associated with the Puritans of the seventeenth century, but this pair of interior photographs clearly reveal how the practice of eradicating all trace of earlier intricate designs has continued into recent times. The covered-over decorations from the early twentieth-century photograph are tiles, placed on the chancel arch and on the wall behind the communion table by Victorian Gothic revivalists.

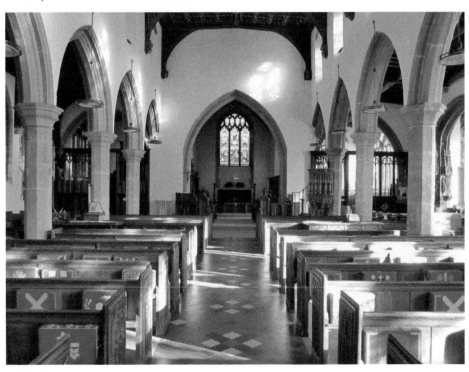

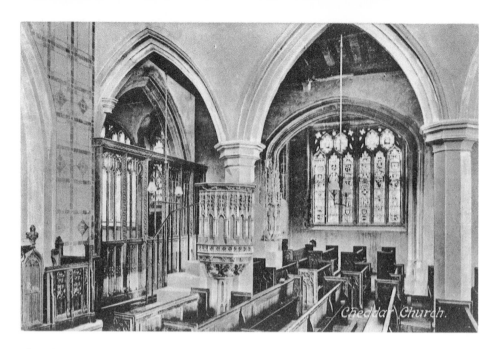

The Vicarage

St Andrew's boasts many fine examples of ecclesiastical architecture and decoration. The pulpit dates from the mid-fifteenth century, and a good deal of beautiful and intricate carving has also survived, including several striking bench ends. Three in the north aisle represent the deadly sins of deceit, gossip and evil speaking – all three sins of the tongue. Although the vicarage still stands, largely unaltered, it no longer houses the vicar of St Andrew's, who instead occupies more modest premises in Station Road. The incumbent in 1883 introduced a tradition from Oxford whereby children in his congregation would climb the steps to the top of the church tower on Ascension Day and sing the hymn 'Hail the Day that Sees Him Rise'; the custom continues to the present day.

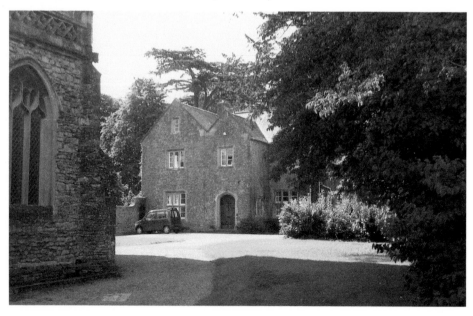

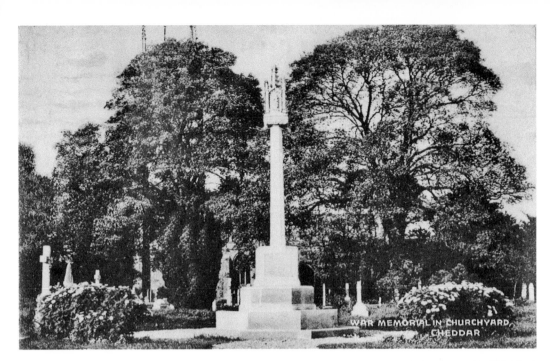

WAR MEMORIAL IN CHURCHYARD, CHEDDAR

Memorial

A memorial to the 'Men of Cheddar' who fell in the First World War can be found in St Andrew's churchyard. This has a closed lantern cross mounted on a tapering stone column set on a square plinth, and it is decorated with carvings depicting St Michael, St George, the Virgin and Child and Christ's Crucifixion.

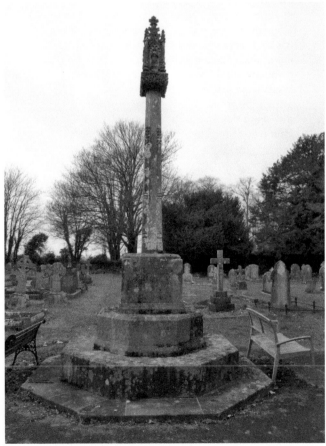

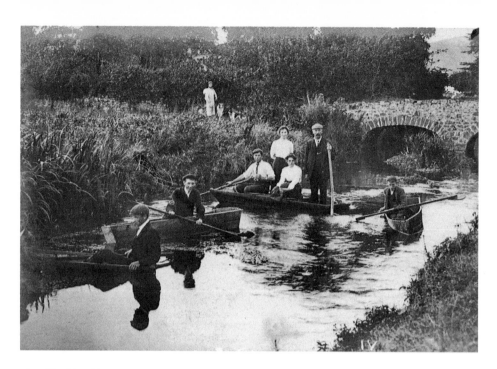

The Cheddar Yeo

Unlike its immediate surroundings, the Cheddar Yeo and its packhorse bridge directly behind St Andrew's church remain largely unchanged. The party of people in the earlier photograph, taken *c.* 1905, are afloat in wooden canoes and a punt. They include several members of the Hill family, who were residents of Cheddar.

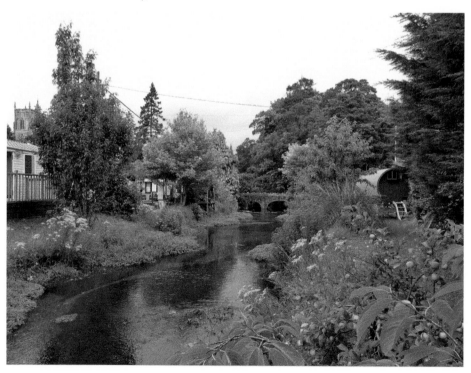

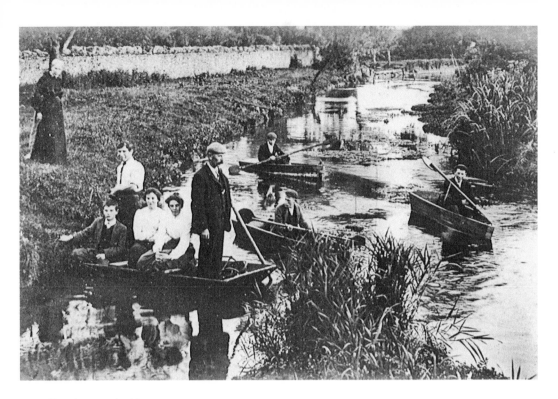

Boating on the Yeo

In this picture the same boating party is photographed in a setting looking along the Yeo away from Church Bridge. The land adjacent to the river on the right now houses the Cheddar Bridge Touring Park. Beyond it is St Andrew's church.

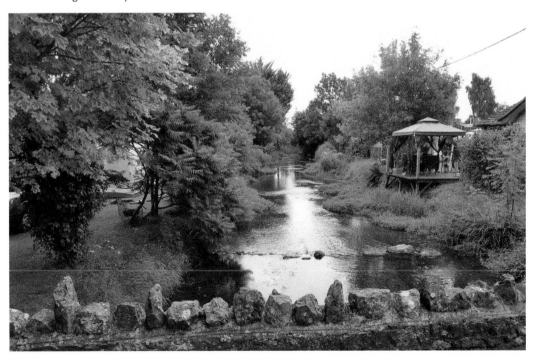

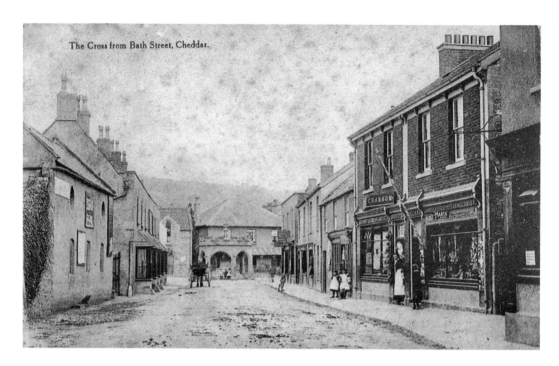

The Cross from Bath Street, Cheddar.

Bath Street

Returning to the Market Cross, Bath Street – which runs to the west – remains the commercial heart of the village of Cheddar. The buildings on the right are largely unchanged. The buildings at the end of Bath Street on the left were the former premises of the Bath Arms Hotel, demolished when the hotel was rebuilt in the 1930s. Adjacent to the hotel is a property that served as a store for an auctioneer.

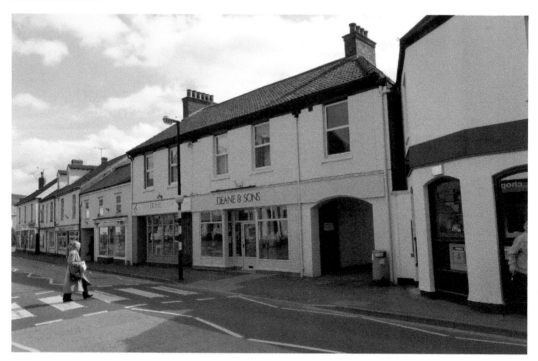

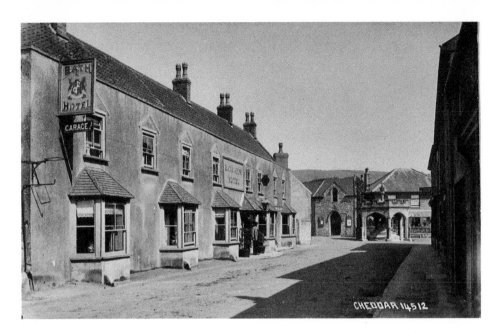

The Tragic Story of Charles Tyley

The present car park for the Bath Arms Hotel replaces the earlier buildings and, presumably, the hotel grounds behind. Of these Nicola Sly has related the tragic story of Charles Tyley who died in 1878 aged twenty-nine: 'The son of a prosperous farmer in Cheddar, he had inherited some property on his father's death and, according to the contemporary newspapers, had somewhat largely indulged in stimulants for a few days ... For his own safety, Tyley was placed in the care of his brother-in-law, Joseph Pavey ... However, at three o'clock in the morning, Tyley managed to escape. His body was found late the following afternoon in the gardens of the Bath Arms Hotel ... Tyley apparently scaled the 8ft-high wall separating the hotel from the road but had fallen from the top, landing face down. When found, his nostrils were filled with earth; it was believed that he had stunned himself when he fell and was suffocated by the garden soil.' (Sly N (2010) *A Grim Almanac of Somerset*)

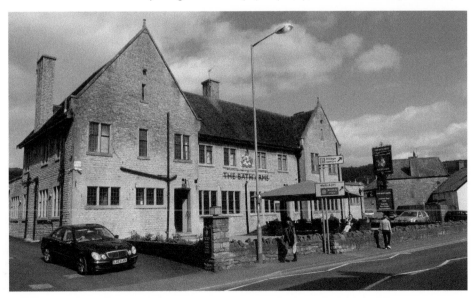

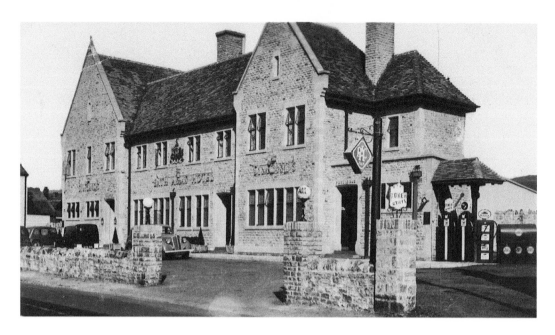

The Bath Arms

The scene of a political riot in 1892, when its windows were smashed by an angry crowd in pursuit of the Radical candidate it was sheltering, the Bath Arms was rebuilt in the late 1930s. Canopies have been added, and the 1940s petrol pumps have long since been removed. Famous visitors in the past include Hannah More, the romantic poets – Coleridge and Southey – and King George VI. The 'Bath' in its name refers to Lord Bath after whom the pub was renamed in 1830 in recognition of his commissioning the restoration of the nearby Market Cross; prior to this it was known as 'The George' or 'The George and Dragon'. A fine collection of archive photographs, several of which appear in this book, can be found adorning the walls of the Bath Arms and its traditional skittle alley.

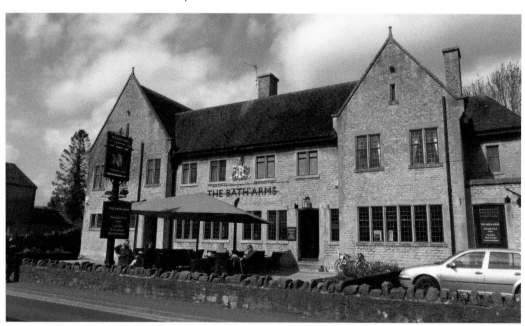

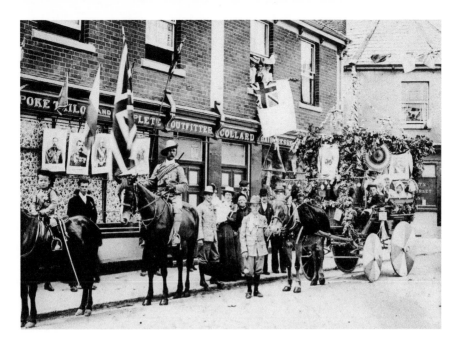

Relief of Mafeking

This early photograph records a parade along Bath Street to celebrate the relief of Mafeking, besieged for several months during the Boer War, on 19 May 1900. The parade culminated in a thanksgiving service held at St Andrew's church. The uniformed rider is Robert Channon, grandfather of Rex Thomas who provided the image. The buildings behind the procession were largely unaltered in the following century. Channons, the tailors, was open until fairly recently. The Wiltshire & Dorset Bank has become the National Westminster Bank. The 1900 photograph was taken by Mr C. H. Collard who was a professional photographer as well as a hairdresser. His hairdressing premises can be seen in the picture; they are now occupied by Deane & Sons.

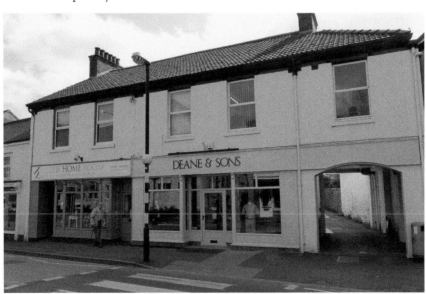

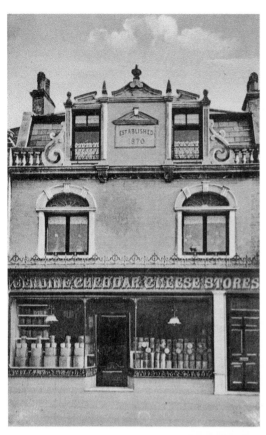

Mr Small

Mr Small, Cheddar's main purveyor
of Cheddar cheese at the end of the
nineteenth century, had a substantial and
ornate shop in Bath Street. The premises
are now occupied by a shop selling
second-hand items for a local charity.

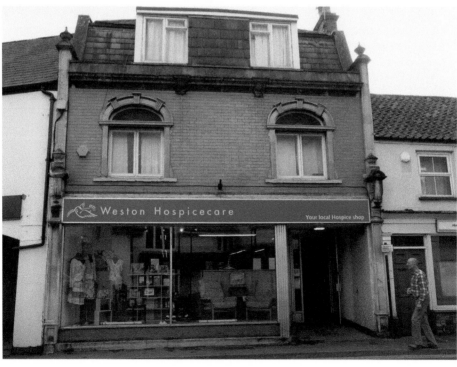

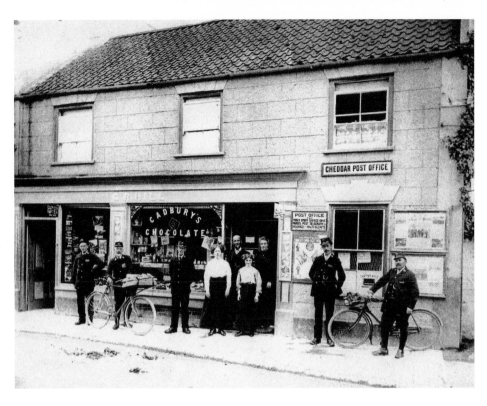

Cheddar's Post Office

Cheddar's post office has occupied the same premises in Bath Street since *c.* 1860.

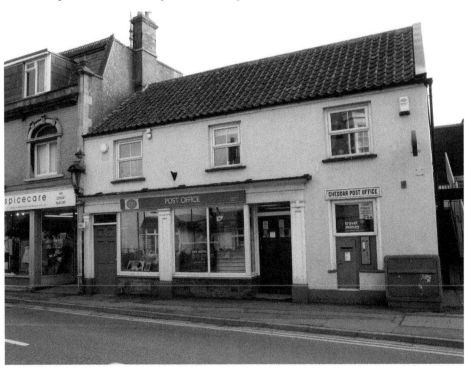

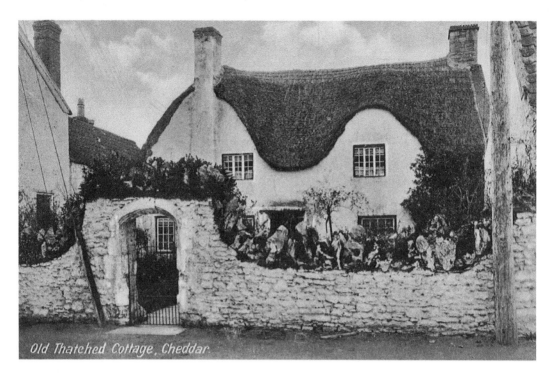

Old Thatched Cottage, Cheddar

Dare House

The charming cottage in the archive photograph above, now replaced by an ugly utilitarian shop, is Dare House, which stood next door to the post office. It was built by James Dare, owner of the *Western Mercury* newspaper. It was demolished around 1950.

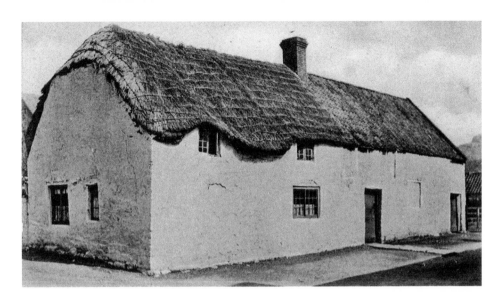

Hannah More's Cottage

In Lower North Street, which runs off to the right at the end of Bath Street, can be found one of Cheddar's most historically significant buildings – Hannah More's Cottage. The original cottage structure is the end adjacent to the road. The farther end was an extension of housing educational pioneer Hannah More's schoolroom on the site of an earlier shed for oxen. The school for the poorer children of the village was endowed by More's friend, the anti-slave-trade campaigning MP, Sir William Wilberforce. When the Sunday school first opened in 1789 – just nine years after Thomas Raikes had opened the first one in Gloucester – 140 children attended the opening day, which was celebrated with a service at St Andrew's church. The attractive thatched roof of the older part of the building, as elsewhere in the village, has been replaced with tiles in more recent times. Since 1953 it has been owned by the parish council and it is used for meetings by various local organisations. The earlier photograph appears on a postcard, which was stamped on 2 October 1909.

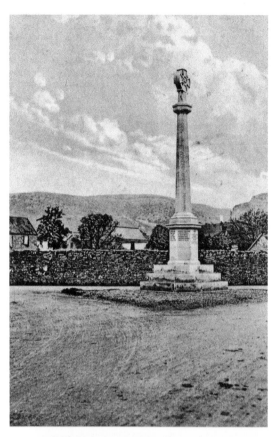

'Ye Who Live On ...'
Bath Street runs into Station Road,
formally called Play Street or Plas Street,
possibly because of its close proximity
to the site of Cheddar's famous Saxon
'palace' in the grounds of the Kings of
Wessex community school. The war
memorial stands at the junction of
Station Road and the A371 in Cheddar.
In the earlier photograph, the names of
those who fell in the First World War
are carved into a hexagonal column. The
postcard is inscribed 'Ye who live on
'mid English pastures green, Remember
us, and think what might have been.'
The recent picture shows the subsequent
addition of brass plates carrying the
names of the dead of both World Wars.
The area where the war memorial stands
has gradually become more built up.

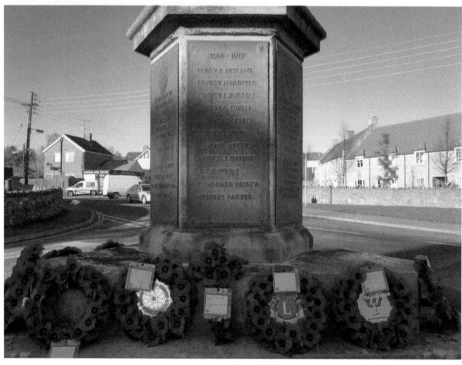

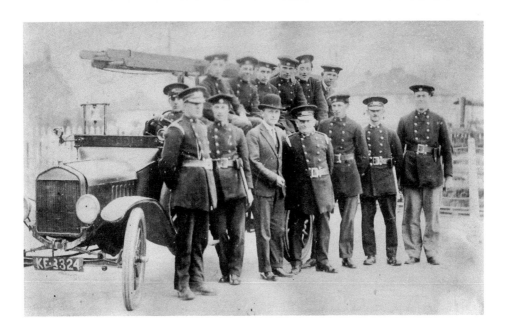

The Fire Station

Where Station Road meets Wideatts Road (identified as 'Widgett's Lane' on the 1902 Ordnance Survey map) can be found The Hayes, along which are sited three important community buildings. Cheddar's fire station, a couple of hundred yards up The Hayes, on the right, was built in 1936. Its roof was specially designed to amplify the sound of its siren, giving warning of air raids in the Second World War. The firemen in the photograph above (*c.* 1930) are standing in front of their Leyland fire engine. To the right is part of the main station building where the engine was housed until the building of the fire station a few years later. Cheddar has had its own fire brigade since 1906. In 1906 it comprised a captain, a lieutenant and ten officers.

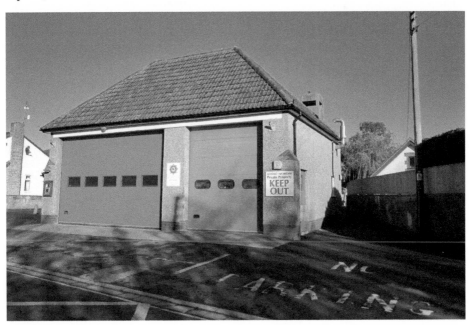

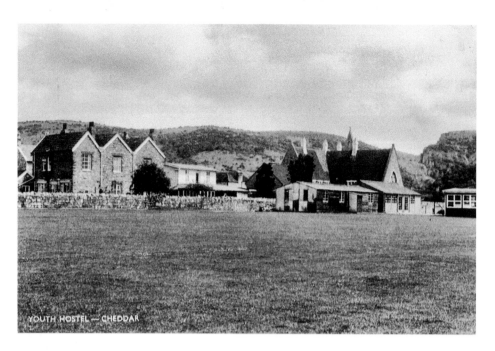

YOUTH HOSTEL — CHEDDAR

The British School

Cheddar's British School, just over the road from the fire station, was established in 1872 – shortly after the 1870 Education Act introduced secular rate-supported elementary schools. On opening it had seventy-two pupils. The village's infant school, Cheddar First School, occupies the surviving buildings of the original structure. The archive picture (shown) dates from around 1905.

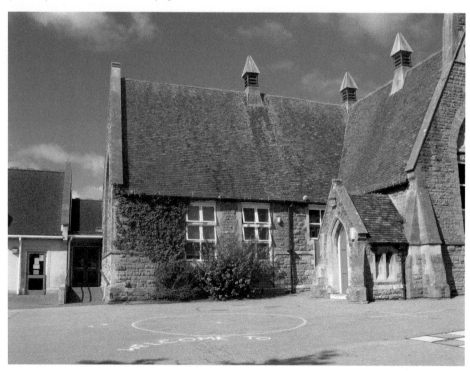

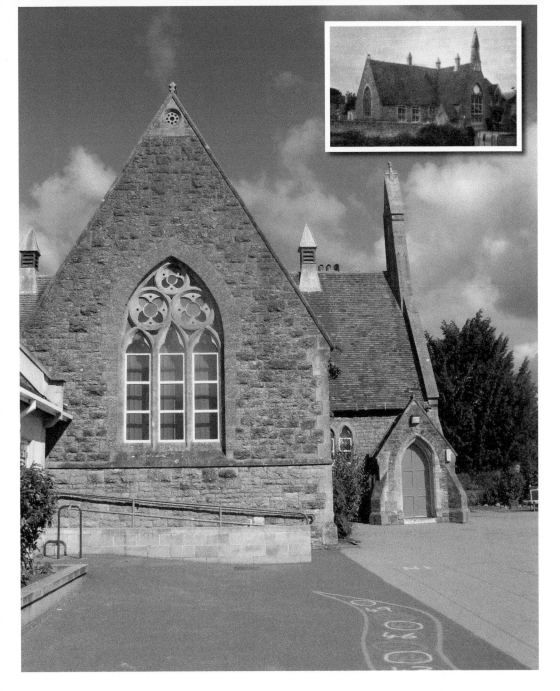

A School at War

The school shown in these images appears almost exactly as it did in 1945 – the year of its first centenary celebration. By the time the Second World War ended, the school had been merged with other local schools, and schools temporarily evacuated to the area due to the higher risk of bombing in other locations. Regular classes since 1940 had included air raid drill – just as well perhaps since on March 31 1944, a number of bombs were dropped in the area leaving many strewn about dangerously unexploded.

Hillfield

'Hillfield', Cheddar's youth hostel, which is located directly behind Cheddar First School, continues to occupy the same Victorian premises shown in the archive photograph above. Although the interior has been modernised and several ancillary structures have appeared in its grounds, essentially the building is unaltered.

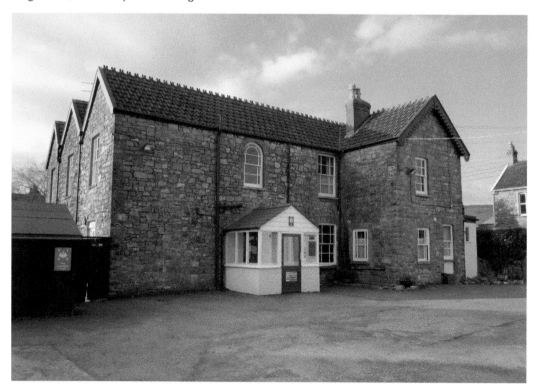

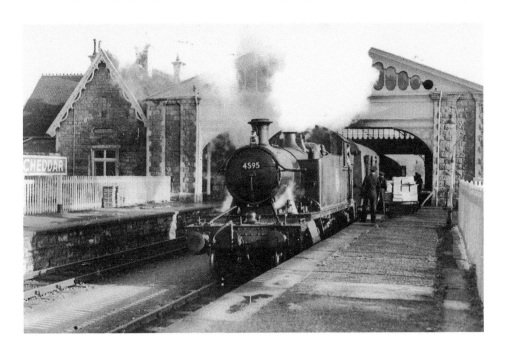

The Railway Station

Returning to the A371, between Wideatts Road and Station Road are the largely intact remains of the old railway station. Cheddar's station was opened in 1869 by the Bristol & Exeter Railway, which became part of the Great Western Railway in 1876. The new station boasted a roof built to a design by Isambard Kingdom Brunel. The engine in the archive picture is a Prairie type – one of only 175 ever manufactured, built sometime before 1930.

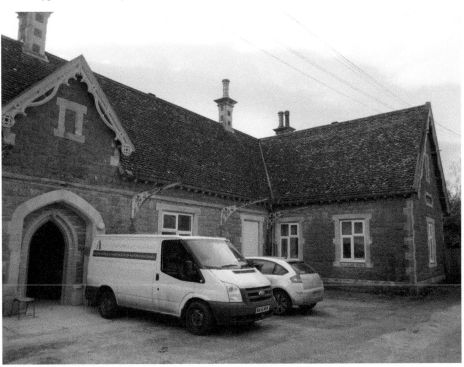

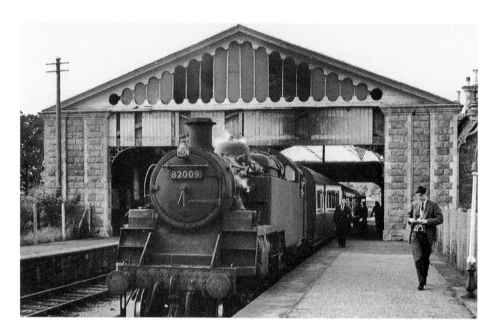

Cheddar's Railway

Although Cheddar's railway carried passengers, mostly pupils of Wells Cathedral School and Wells Blue School, and light goods, including, of course, strawberries, most of its carriage was that of heavy goods – stone from the Batts Combe and Crow Catchpole quarries and lime produced by the Carrow Rock Lime Co. By 1886, it was laying on five passenger trains a day to carry tourists to the view the famous sites at both Cheddar and Wells. The stationmaster's house is now a private residential property with the name 'Station House'. The engine shown in this archive photograph is a BR Standard Class 4 Tank, – one of 155 built between 1951 and 1957.

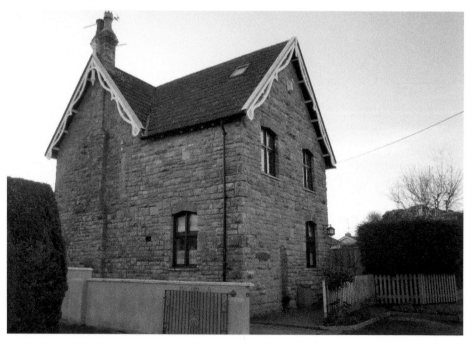

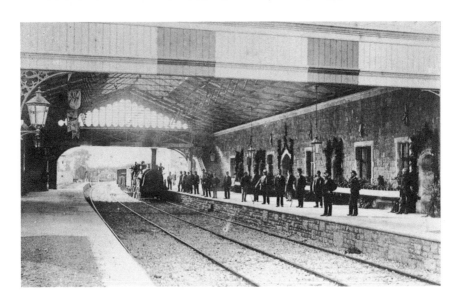

Wells Cathedral Stonemasons

At the time of the official opening of the line, a Bristol newspaper commented, 'At Cheddar the directors were invited into the station where an elegant refection of cake and champagne was prepared for their refreshment. The vicar said he was deputed to welcome them to Cheddar. In his opinion the main cause of the prosperity of the railway was that the directors were a God-fearing body (*hear, hear*). They had not run on the Lord's Day those monster excursion trains by which the people were demoralised. He wished them all success for their line (*loud applause*). Several bottles of champagne were then opened and the usual toasts were drunk without stint.' (Coysh A. W., Mason E. J., Waite V. (1954) *The Mendips*, Robert Hale, p. 125) Since 1984 the station has been home to Wells Cathedral Stonemasons, specialists in the restoration and conservation of historic buildings for over thirty years.

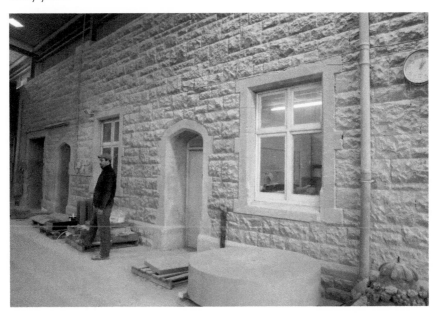

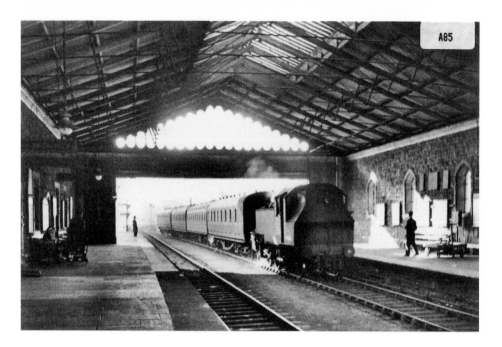

Cheddar's Railway History

Although the rails have long since been lifted, plenty of evidence remains to remind the visitor of Cheddar's railway history including this bridge. Shortly after its opening, a Bristol newspaper reported, 'Leaving the main line at Yatton the branch proceeds through nearly ten miles of the most beautiful and picturesque scenery of mid-Somerset. The making of the track for a considerable part of the route has been comparatively easy; the natural level of the valley has been followed as much as possible, and the line passes over and under some half a dozen bridges in its course.' (Coysh A. W., Mason E. J., Waite V. (1954) *The Mendips*, Robert Hale, p. 125)

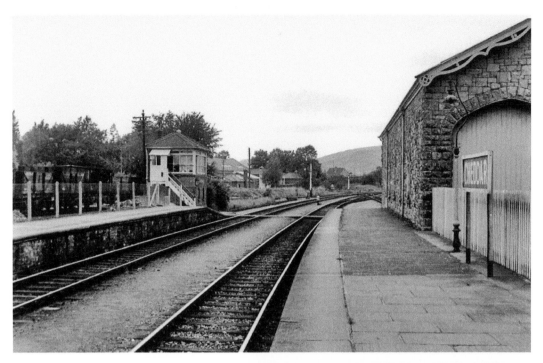

Sustran's Campaign and the Steam Club

The 'Strawberry Line' is the target of a concerted 'Sustrans' campaign to provide an attractive route for walkers and a safe cycling path all the way from Cranmore near Shepton Mallet (where steam trains still run) to Clevedon, via Cheddar. Parts of it are already accessible, and a cycle ride or stroll past the reservoir to Axbridge provides a very pleasant excursion on a warm day. Steam locomotion is not altogether a thing of the past in Cheddar – a thriving Steam Club can be in Sharpham Road, between the station and the reservoir, which boasts a 400-yard model railway track in 32mm and 45mm, and a decent sized lake for model steamboats.

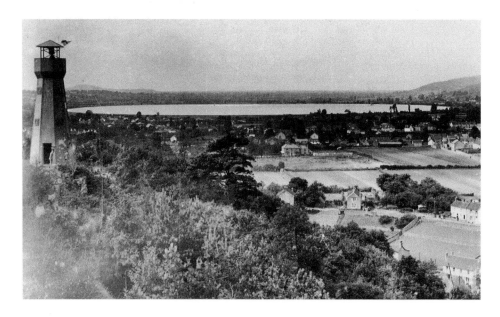

Cheddar Reservoir

A little way along the Cheddar–Axbridge cycleway lies, to the left, Cheddar's great circular reservoir, also known as Axbridge Reservoir. It was opened in 1938 to supply Bristol with water and remains a significant and important feature in the Cheddar landscape. It is supplied by water from the springs supplying the Yeo River in Cheddar Gorge. Members and guests of the Bristol Corinthian Yacht Club have sailed upon it since 1947 when it became the first water supply reservoir to be used for this form of recreation. It attracts numerous visitors including windsurfers, fishermen, walkers, cyclists, and, as a designated Site of Special Scientific Interest, bird watchers are drawn by its great variety of wildfowl in winter. Discussions are ongoing for the building of an adjacent second reservoir of a similar size. The archive photograph is taken from the ridge at the top of Jacob's Ladder.

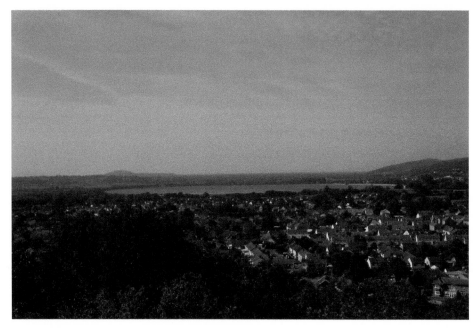